IMAGES
of America

LOS ANGELES'S ANGELS FLIGHT

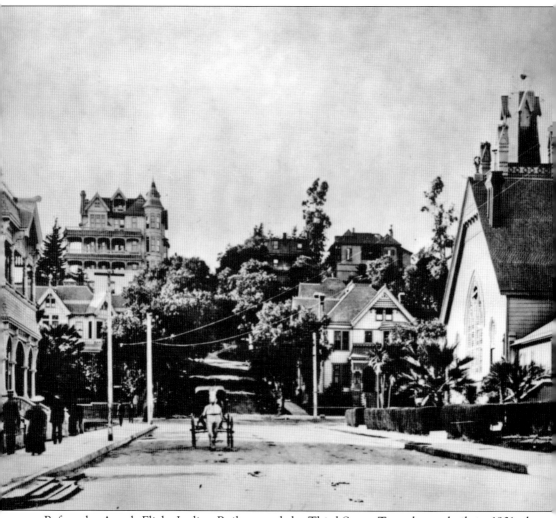

Before the Angels Flight Incline Railway and the Third Street Tunnel were built in 1901, the intersection of Third and Hill Streets was in the middle of a placid, residential neighborhood. In this westward view up Third Street toward Bunker Hill in the 1890s, Margaret Crocker's ridge-top Queen Anne mansion at the corner of Third and Olive Streets dominates the skyline; it was visible for miles. On the far right, at the northeast corner of Third and Hill, is the First Congregational Church. Across Hill Street (facing the camera) on the northwest corner is the home of Rose McCoy. (Security Pacific Collection/Los Angeles Public Library [LAPL].)

ON THE COVER: In the early 1940s, Angels Flight's two trolley cars together made about 1,000 daily trips up and down Third Street on the side of Bunker Hill, ferrying passengers between busy Hill Street at the bottom and Olive Street at the top. Four conductors, working three shifts a day from 6:30 in the morning to 20 minutes past midnight, tried to not keep people waiting for more than a minute. The fare was a nickel going up; the ride down was free. (Photograph by William Reagh; Security Pacific Collection/LAPL.)

IMAGES
of America

LOS ANGELES'S ANGELS FLIGHT

Jim Dawson

ARCADIA
PUBLISHING

Copyright © 2008 by Jim Dawson
ISBN 978-0-7385-5812-7

Published by Arcadia Publishing
Charleston SC, Chicago IL, Portsmouth NH, San Francisco CA

Printed in the United States of America

Library of Congress Catalog Card Number: 2007939188

For all general information contact Arcadia Publishing at:
Telephone 843-853-2070
Fax 843-853-0044
E-mail sales@arcadiapublishing.com
For customer service and orders:
Toll-Free 1-888-313-2665

Visit us on the Internet at www.arcadiapublishing.com

This book is dedicated to the city of Los Angeles.

Contents

Acknowledgments		6
Introduction		7
1.	Dreams of Bunker Hill	9
2.	Colonel Eddy's Celestial Railway	17
3.	A Landmark on Wheels	35
4.	Postcard Perfect	49
5.	"Funiculì, Funiculà"	59
6.	Court Flight	67
7.	Hard-Boiled Memories	75
8.	Train to Nowhere	87
9.	End of the Line	101
10.	Back to the Future	119

Acknowledgments

The author would like to thank Patricia Adler; Mary Katherine Aldin; Keith Anderson; Thom Anderson; Lynne Bateson; Bob Birchard; Eddy Brandt's Saturday matinee; Mimi Brody; Edgar Bullington; Carolyn Cole of the Los Angeles Public Library's photograph collection; historian Virginia L. Comer; Kim Cooper; Brent C. Dickerson; Dennis Doros; Donald Duke; Alan Fishel; Roy W. Hankey; Arnold Hylen; Kate Karp; Bill Kay; Gary Leonard; Vickie Lockhart of the California State Library's California History Room; Rick Mechtly; William Mitchell; Paul Politi; William Pugsley; Lane Quigley; Earl Reinhalter; Jeffrey Robbins; my patient editor, Jerry Roberts; Richard Schave; Andy Schwartz; Dana Smith; Dace Taube of the University of Southern California's Special Collections; gentleman Jim Walker; Marc Wanamaker of the Bison Archives; Eric Warren of the Eagle Rock Valley Historical Society; John Welborne of the Angels Flight Railway Foundation; Walt Wheelock; and Ian Whitcomb.

The images without credit are from the author's collection. Angels Flight and the images of the Angels Flight Railway and cars are trademarks of the Angels Flight Railway Company and are used with permission.

INTRODUCTION

In the world of incline railways, Angels Flight was a star almost from the moment it opened in the heart of Los Angeles on New Year's Eve of 1901. Though formally called the Los Angeles Electric Incline Railway, its rolling stock of twin trolleys barely qualified the pipsqueak franchise as a railroad operation. Nobody ever called it the Bunker Hill Line. Even its nickname, the World's Shortest Railway, was hyperbole because an earlier incline in Dubuque, Iowa, was shorter. But Angels Flight was full of quirky personality and charm. Hollywood would have loved it, if Hollywood were anything more than a big citrus grove in 1901. Certainly, the new postcard industry took a shine to Angels Flight. Winter tourists and visiting businessmen were so amused by the little metal cars running up and down the side of Bunker Hill that they sent millions of Angels Flight postcards back home with scribbles like: "We went up to the top of this hill in the little cable cars where you get a grand view of everything."

From the beginning, there was confusion about whether the railway's name had an apostrophe, which would have made it the flight of one angel, but in time, "Angels Flight" became the preferred spelling. It is unclear why Col. James Ward Eddy, the man who built Angels Flight, settled on the whimsical idea of his enterprise being a "flight of angels," other than its location in the City of Angels. Perhaps he was inspired by a line at the end of chapter one in the Book of John: "Hereafter ye shall see heaven open, and the angels of God ascending and descending upon the son of man." Certainly, Angels Flight had a double meaning that any literate, dawn-of-the-20th-century Angeleno could appreciate. A *flight* was a group of birds—or angels—flying in formation through the air, or it was a stairway. Though winged angels (from the Greek *angelos*, or messenger) appeared in the earliest books of the Bible, they never traveled in flocks—at least not until Jesus Christ, in the Book of Matthew, threatened to call down "twelve legions" of them. The idea of a flight of angels did not come about until the 16th century, when Shakespeare consigned Hamlet to eternity with "Good night, sweet prince, and flights of angels sing thee to thy rest." On a more earth-bound level, the railway served as a movable staircase, a convenient substitute for the real flight of 123 concrete steps and landings that climbed the hill alongside it.

In November 1901, a month before the railway's inauguration, Colonel Eddy amplified the Biblical allusion by christening the trolleys *Sinai* (after the Old Testament's Mount Sinai, where God descended from heaven) and *Olivet* (from the New Testament's Mount Olive, where Christ ascended into heaven).

Angels Flight was a graceful operation. The white, open-air cars (later enclosed and, later still, painted orange with black trim like Halloween carriages) glided skyward with a minimum of friction and a maximum of style. They did not chug and puff and make a big fuss; tethered to each other by a long steel cable, they simply used their counterweight to gently pull each other up and slow each other down—all with the help of an electric motor and a system of wheels and pulleys at the top. Angels Flight also had a touch of elegance because it reached up to an aerie where the Queen Anne mansions of the city's Brahmins cast Gothic silhouettes against the sky.

Unfortunately, this very attachment to Bunker Hill would in time make Angels Flight irrelevant. As early as the 1930s, writers like Raymond Chandler noted the hilltop community's slide into Bohemianism and genteel poverty. A decade later, as the old homes and family hotels deteriorated into tenements and flophouses, Hollywood directors used the mean streets as real-life atmosphere for dozens of gritty films noir. When Los Angeles eventually ripped up those streets, tore down the dilapidated buildings, and hauled everything away, it packed up Angels Flight like a toy electric train, put the cars into mothballs for what was supposed to be a year or two, and leveled Bunker Hill into a mesa for the boulevards and monoliths of what the city's urban designers hoped to be

a gleaming acropolis (or, as some critics tagged it, a corporate Forbidden City). Not until three decades later, in 1996, did Los Angeles get around to restoring Angels Flight—but only as a tourist relic on a vacant hillside lot half a block south of its original location. The new railway lasted five years before a fatal accident derailed the cars.

But now, with the rebirth of Angels Flight as a part of a revitalized Bunker Hill, a new era begins for Los Angeles's only movable landmark. City historians have noted that more than 100 million people rode on the original railway. Perhaps a second 100 million will eventually make the trip.

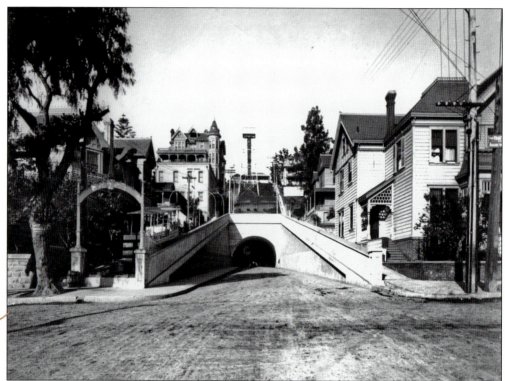

Col. J. Ward Eddy's original 325-foot-long Angels Flight lasted only from 1901 to 1905. Broken into two grades, it banked in a steep angle down the bluff from Olive Street to Clay Street (really an alley) and then leveled off gently down to Hill Street alongside the entrance to the Third Street Tunnel. In those days, Angels Flight was part of a leafy neighborhood of middle-class homes. On the northwest corner, across Third Street from Angels Flight, was the Rose McCoy house (right). Next to the archway on the southwest corner was the residence of former city councilman and California Livery Stable owner William Ferguson. On up the hill, the Benn residence sat near the southeast corner of Third and Clay Streets. The Newton family owned the large square apartment building across Clay on the southwest corner; and looming above them all at the summit was the Crocker mansion, which by 1901 was a boardinghouse owned by Aimee Crocker, the daughter of Sacramento magnate and former California Supreme Court justice Edwin B. Crocker and socialite Margaret Crocker—both dead by the time Angels Flight opened. This impressive Victorian structure was torn down in 1908 and was replaced the following year by the local headquarters of the Benevolent and Protective Order of Elks. (Security Pacific Collection/LAPL.)

One

DREAMS OF BUNKER HILL

The Los Angeles Basin was a coastal plain inhabited only by a band of Cabrielino Indians when Spanish settlers founded El Pueblo de la Reina de Los Angeles in 1781. Over the next 85 years, the dusty little town spread westward and southward as the population grew. But one area that farmers and homesteaders avoided was a long, treeless promontory whose steep grades resisted their mule-drawn *carretas*. Its sagebrush and chaparral provided little grazing for sheep and cattle. Nobody thought the hill had any worth until a French Canadian–born merchant named Prudent Beaudry bought a big chunk of it—20 acres—for $517 at a sheriff's auction in 1867, with the idea of developing a residential neighborhood. His property—known as the Mott Tract after it was surveyed the following year—was bordered by Fourth Street to the south, Hill Street to the east, Second Street to the north, and Charity Street (later Grand Avenue) to the west. Beaudry subdivided his land and sold lots on the installment plan, promising "every industrious mechanic a chance to secure a home in the Most Elegant Part of the City." He cofounded Los Angeles's first water company and built two reservoirs, 11 miles of iron pipe, and a pumping system that brought up water from the Los Angeles River. He graded streets, paved them, and planted rows of shade trees. In the meantime, other speculators were developing adjacent properties and shaving down parts of the hillside to make the area more accessible. After he became the city mayor, Beaudry celebrated America's 1875 centennial commemoration of the Revolutionary War's Battle of Bunker Hill by conferring the name on his hilltop community.

Los Angeles was in the midst of a housing boom that turned Bunker Hill into a prized residential neighborhood where gentlemen who were making fortunes in the energized flatland of downtown could build their mansions. Then, throughout the 1890s, came the construction of dozens of hotels and rooming houses to support the city's commercial district. By 1899, Bunker Hill was a thriving community.

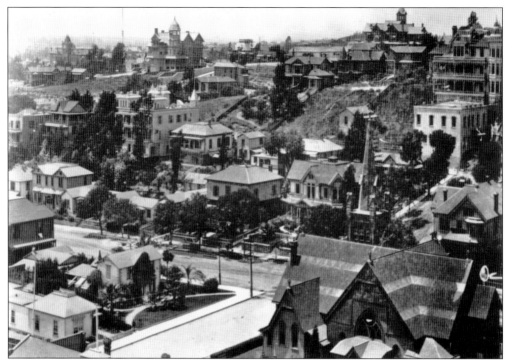

This 1880s panorama looks southwest from the Los Angeles City Building toward Bunker Hill. Third Street is at the right, with the First Congregational Church in the lower corner and the Crocker mansion at the top. The large building to its left was a hospital on Charity Street (later Grand Avenue). Farther left, the Monnette house (with pointed cupola) stood at Fourth and Olive Streets. (Security Pacific Collection/LAPL.)

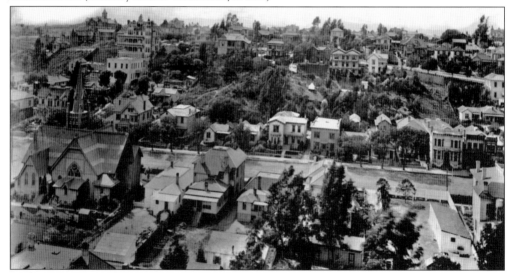

In this more comprehensive view, the Crocker mansion is in the left quarter of the photograph. Because the house faced away from the city, its architect created a magnificent four-storied backside with a turret and a two-story veranda. After the construction of Angels Flight beneath it in 1901, the mansion became Bunker Hill's most photographed building. (University of Southern California, Special Collections.)

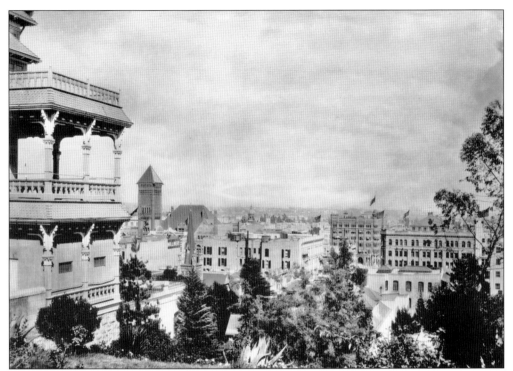

In this reverse view from Bunker Hill, looking past the Crocker veranda (left) toward downtown Los Angeles, the 1888 city hall on Broadway, south of Second Street, is the most visible building. The panoramic photographs on the opposite page were taken from its tower. (University of Southern California, Special Collections.)

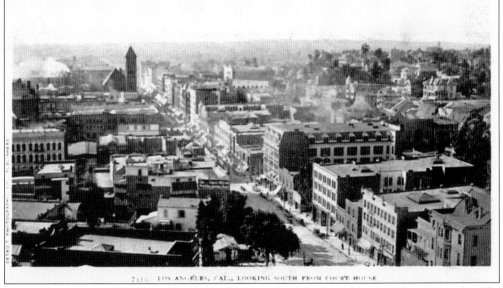

This early postcard, looking south along Broadway in downtown Los Angeles, shows that the growing business district was beginning to reach residential Hill Street (one block west of Broadway) and the wilds of Bunker Hill above it (at the right). The sandstone city hall is clearly visible on the left.

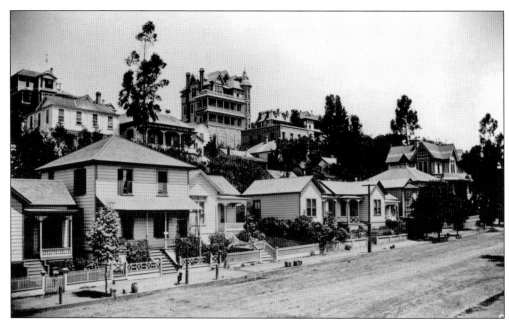

America's post–Civil War Industrial Age created a wealthy class of bankers, railroad and factory owners, and land speculators who flaunted their abundance with Queen Anne mansions, the most breathtaking example of what is now called Victorian architecture. The Crocker home, built by Margaret Crocker after her husband Judge Edwin Crocker's 1875 death, was Bunker Hill's most conspicuous Queen Anne. (Security Pacific Collection/LAPL.)

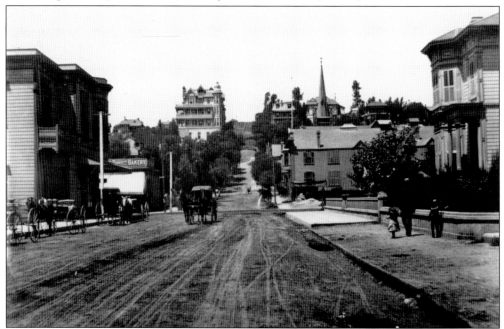

In this mid-1880s westward view along Third Street, the Crocker mansion dominates the skyline from four blocks away. Its bric-a-brac Queen Anne design (named after Great Britain's early-18th-century monarch) featured steep roofs, gables, verandas, lacy spindles, and towers popping out everywhere in a rebellion against symmetry. (Security Pacific Collection/LAPL.)

The Rose McCoy home (seen here around 1890) stood on the northwest corner of Hill and Third Streets. After Angels Flight was built on the opposite side of the street (to the left), the house was moved halfway up the hillside to Clay Street and expanded into a rooming house. (Security Pacific Collection/LAPL.)

The First Congregational Church was built in 1883 at the northeast corner of Third and Hill Streets, completing the image of a comfortable residential neighborhood. The photographer stood catty-corner across the street, roughly where Angels Flight's bottom arch would be built a dozen years later. (University of Southern California, Special Collections.)

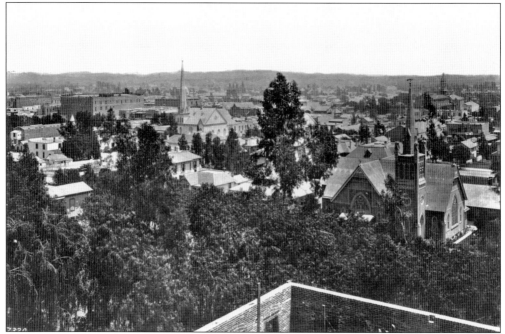

In this 1880s shot from Margaret Crocker's veranda, a building later known as the Nelson house is under construction below at the southwest corner of Clay Street. Beyond it, at the right, is the First Congregational Church at the bottom of the hill. (University of Southern California, Special Collections.)

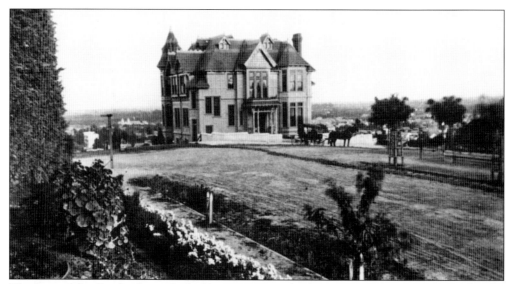

The front of the Crocker home looked less impressive than its posterior. It was a vanguard of the Queen Anne design, introduced to America in 1876. By the time the style faded around 1910, Bunker Hill's Queen Annes were rooming houses. Margaret Crocker died in 1901; daughter Aimee sold the mansion in 1905, and it was torn down three years later. (Security Pacific Collection/LAPL.)

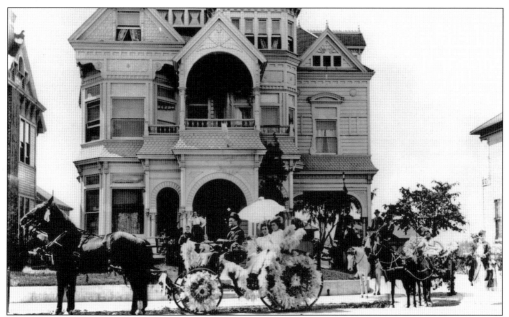

"The Castle" was built at 325 South Bunker Hill Avenue by the Chicago Armour family in 1882, but the 20-room mansion became better known as the longtime residence of paving contractor D. F. Donnigan. The Castle would eventually be one of the last two houses removed from Bunker Hill. (Security Pacific Collection/LAPL.)

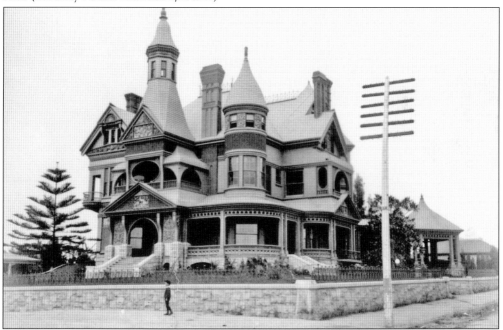

Lewis L. Bradbury's 30-room mansion stood at the corner of Court and Hill Streets, three blocks north of Third Street where Hill Street climbed up to the ridgeline of Bunker Hill. The house was built in 1887 in the American Renaissance style, featuring decorative woodwork inspired by California vegetation. The Bradbury home later became a film studio. It was demolished in 1929. (Security Pacific Collection/LAPL.)

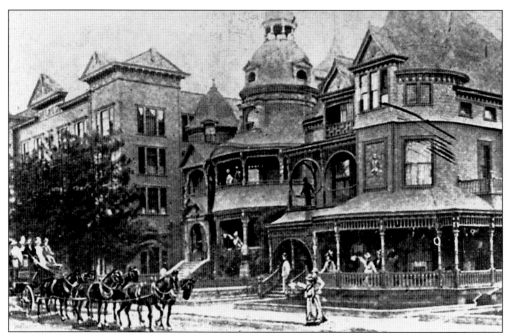

The elegant, 50-room, domed Melrose family hotel (middle) at 130 South Grand Avenue, seen here around 1895, was built in 1887. The house on the right, located at 142 South Grand, was businessman Robert Larkin's residence until it was converted into the Richelieu Hotel in 1891. (University of Southern California, Special Collections.)

Prudent Beaudry laid out the streets of his Bunker Hill development on an orderly grid. Grand Avenue was originally called Charity Street. Angels Flight and Court Flight are delineated in black. The break in Fourth Street between Flower and Hope Streets was created by a steep hill. (Hand-drawn map by Earl Reinhalter.)

16

Two

Colonel Eddy's Celestial Railway

Third Street was the center of the Bunker Hill neighborhood, but Prudent Beaudry graded and paved it only as far as Olive Street, at the crest of the steepest, longest hillside above downtown's Hill Street. For the sharp drop to Clay Street midway down the slope, he built a zigzag public stairway to connect with the city sidewalk between Clay and Hill Streets. Beaudry died in 1893 without improving the right-of-way any further. Third Street was still inaccessible to wagon teams and buggies a few years later when city engineers chose it as the eastern terminus of the Third Street Tunnel, running east and west beneath Bunker Hill.

In May 1901, a few months before the tunnel opened, a 69-year-old Illinois transplant named Col. James Ward Eddy petitioned the Los Angeles Common Council for the right to build a vertical Third Street railway between Hill and Olive Streets out of his own pocket. He had moved to the city six years earlier as a surveyor for the Kern and Los Angeles Electric Power Company, but with his peripatetic background as a Civil War officer, Chicago lawyer, Illinois state senator, railway construction engineer, and president of a failed Arizona railroad, the widower was feeling restless. He lived with his teenage grandson at 524 South Hill Street, where every day he looked up and saw the mansions on Bunker Hill, so near and yet so far away because there was no easy way of reaching them. It was his grandson, Simeon Gillette, who first wondered out loud why somebody didn't just build a cable car up the side of the hill. That got Eddy to thinking, "Yes, why not?"

Los Angeles already had several electric cable car lines. One ran along Hill Street past Eddy's house and turned east on Third. But Eddy, with his railroad background, knew that a short-line cable car, though feasible, would be impractical on the steep embankment. A more economical system was the incline railway, or funicular, which used two counterbalanced cars to minimize the use of electrical power by taking turns pulling each other up the hill.

In this mid-1901 view looking up Third Street toward Hill Street, just before Colonel Eddy built Angels Flight, the Third Street Tunnel—running beneath Bunker Hill to Hope Street—was nearly finished. The Pacific Electric streetcar line ran along Third and Hill Streets and was not part of Angels Flight. (Security Pacific Collection/LAPL.)

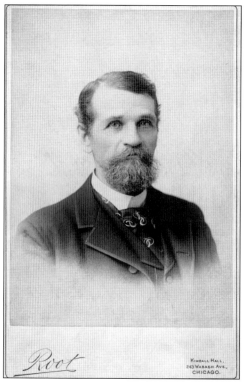

Col. James Ward Eddy (seen here in the 1870s) was born in Java, New York, in 1832. After moving to Illinois at 21, he became a lawyer and entered state politics. Eddy earned his military rank during the Civil War. Later he turned to engineering and worked with railroads. Eddy and his wife, Isabella, settled in Los Angeles in 1895. (Eagle Rock Valley Historical Society.)

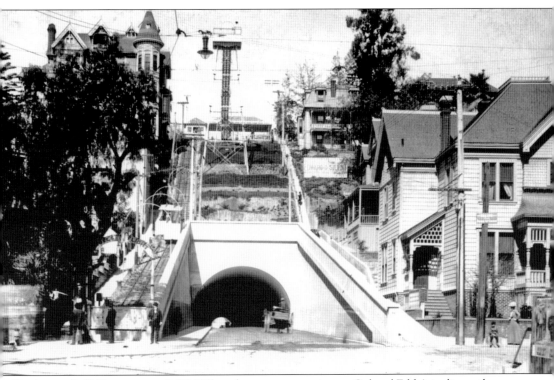

On August 2, 1901, contractor J. W. Gillette began construction on Colonel Eddy's incline railway. He broke it into two different grades that followed the hillside's contours. In all, the 30-inch-gauge railway was 325 feet long, The project included a 123-step concrete stairway all the way down the north side of the right-of-way from Olive to Hill Streets because the city council stipulated it in Eddy's building permit "to prevent a monopoly on the means of ascent" on what was otherwise a public street. Also part of the deal was that Eddy would create a park between the steps and the railway. The open-air metal cars, *Sinai* and *Olivet*, were painted a cream-white with black trim. For protection, they had an overhead canvas held in place by pipe arches that held small electric lights. Each car seated 10 passengers. *Sinai* took the northern loop at the center of the incline and *Olivet* the southern loop. The ride lasted less than a minute and cost each ascending passenger one penny; the trip down the hill was free. (California History Section, California State Library.)

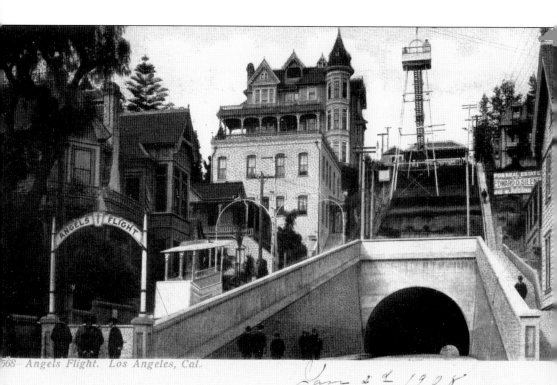

Standing in a crowd at the top of Bunker Hill on the sunny morning of December 31, 1901, Colonel Eddy opened his enterprise to the public. Mayor Meredith P. Snyder arrived a few minutes late on one of the trolleys and delivered a speech praising the city's progress. Though the funicular's official title was the Los Angeles Incline Railway, the lettering atop both cars said "L.A. Electric Incline R.R." Neither name mattered because from the beginning, everyone called it Angels Flight—the words written on the metal arch on Hill Street beneath a 2-foot-high cherub in a flowing robe. A canopied plaza next to the engine house at the top of the hill on Olive Street was called Angels Rest. Just below it, in the grassy strip called Eddy Park, Colonel Eddy built a 100-foot-high steel observation tower complete with a camera obscura—a dark, windowless chamber that was literally the inside of a camera, with a small round aperture projecting an image of downtown Los Angeles upon a glass surface inside—donated by Mayor Robert F. Jones of Santa Monica.

In these c. 1902 postcards, Angels Flight was still a charming trolley system surrounded by homes and mature trees. At the bottom of the hill, next to the archway, was William Ferguson's house. Behind it was the Benn house. On Clay Street (running across the top of the tunnel), the Newton family owned the large square building; and above them all was the Crocker mansion. In 1904, Colonel Eddy bought the small house visible on the north side of Eddy Park (below), tore it down, and built the Hill Crest Inn. The house below it (at the corner of Clay Street) was also razed, and the Rose McCoy house on the corner of Hill Street (barely visible at lower right) was moved up the hillside to replace it.

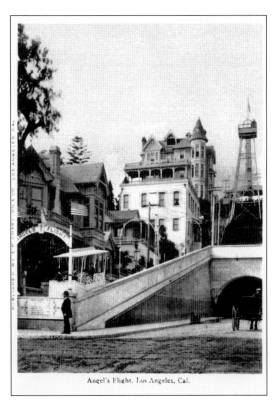

Angel's Flight, Los Angeles, Cal.

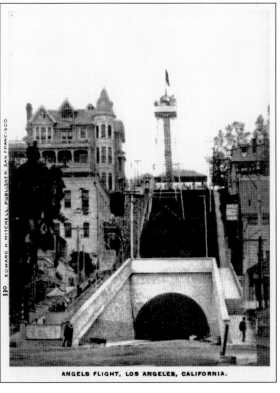

ANGELS FLIGHT, LOS ANGELES, CALIFORNIA.

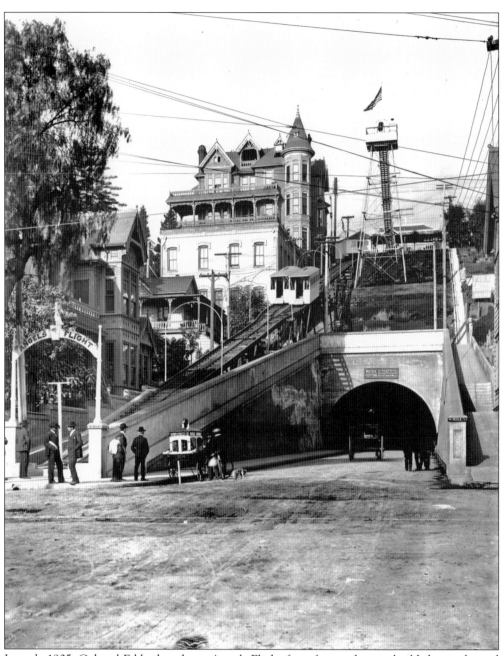

In early 1905, Colonel Eddy shut down Angels Flight for a few weeks to rebuild the tracks and elevate them above Clay Street. The old tracks had required a pulley-and-roller system on Clay that became a maintenance nightmare. (Narrow Clay Street is hidden behind the wall above the tunnel in this c. 1905 photograph.) Reconstruction created a uniform 33-degree grade from top to bottom, which shortened the railway's length from 325 to 315 feet and required a set of new cars properly angled for the revised slope. Eddy replaced the open-air metal trolleys with enclosed wooden cars that seated 16 people instead of 10. In this photograph, the new *Olivet* and *Sinai* pass within inches of each other above Clay Street. The sign above the tunnel reads: "Notice, $50.00 fine for riding or driving through this tunnel faster than a walk." (Bison Archives.)

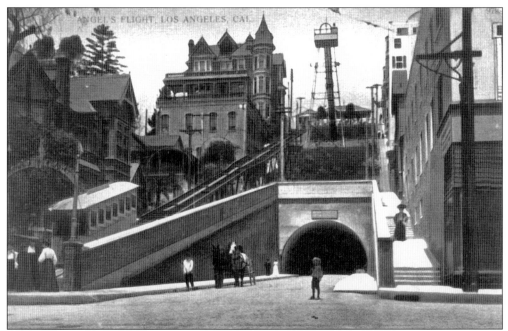

In these post-1906 postcards, the Angels Flight neighborhood is still residential and relatively placid, but the north side of Third Street has changed considerably in the previous year or two. The McCoy house has been moved roughly 50 feet up the Third Street hill to Clay Street, and the three-story St. Helena Sanitarium has been built in its place on the corner of Hill Street. Midway up Third, above Clay, the rambling Sunshine Apartments, a clapboard structure built around 1905, has replaced the earlier single-family home. At the top of the hill at Olive Street is the new Hill Crest Inn.

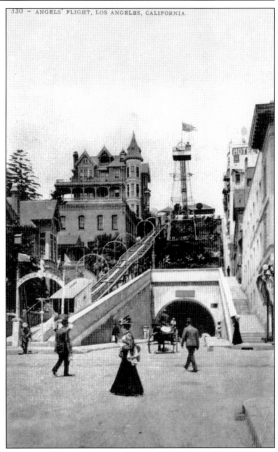

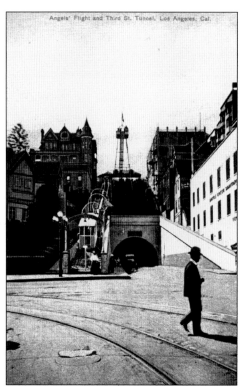

These postcards more clearly show the dramatic changes on the north side of Third Street. Now that Bunker Hill's population was growing, contractors rushed in to build hotels, apartments, and rooming houses. The Crocker mansion had already been converted into an upscale family boardinghouse years earlier. On the opposite corner, Colonel Eddy's new Hill Crest Inn sprawled down the side of the hill—two stories in front and five stories at the bottom. Below it was the Sunshine Apartments, a four-story rooming house with three wraparound porches built upon a 10-foot-high retaining wall on the corner of Clay Street.

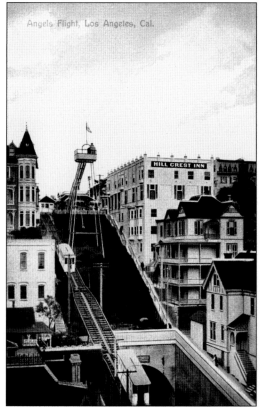

Col. J. W. Eddy printed this "trade card" around 1906 to advertise his new, improved "Angel's Flight" (with an apostrophe). Trade cards were popular at the time but were meant for personal delivery only. This card exceeded the post office's postcard size limit, and the back had not been left blank according to regulation. Like any advertisement, it extolled the benefits of riding Angels Flight and enjoying its many features, including the observation tower. Note that by now, Colonel Eddy had petitioned the city to allow him to raise the price of a ride up Angels Flight from a penny to a nickel.

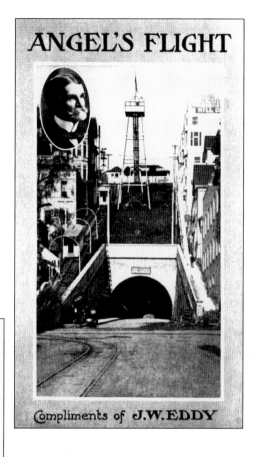

Have You Visited the
"Angel's Flight"

IF NOT WHY NOT?

IT IS THE MOST UNIQUE, INTERESTING AND PICTURESQUE INCLINED RAILWAY IN THE WORLD

IT is in the heart of the city—Hill and Third Streets, Los Angeles, Cal. The ride is inspiring and perfectly safe. The view from the tower—"Angel's View"—is grand beyond compare, overlooking city, sea and mountains. The Camera Obscura, the most perfect in existence, puts a beautiful living picture of Third Street and vicinity on canvas before you.

Fares 5 cents, three for 10 cents, ten for 25 cents, 100 for $1.00. Angel's View with Camera Obscura 5 cents, three for 10 cents. Rest Pavilion, "Angel's Rest," overlooking city, Eddy Park and Fountain FREE. Easy chairs. Come and bring your friends and enjoy yourselves.

Phones: Home 6013 / Main 9321

(OVER) Geo. Rice & Sons, Inc., Los Angeles

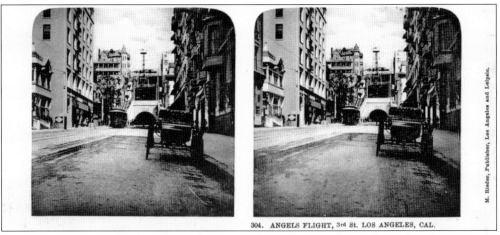

304. ANGELS FLIGHT, 3rd St. LOS ANGELES, CAL.

The stereoscope, popular from the mid-1800s to the 1930s, was a binocular gadget that viewed a card with two photographs of the same object taken from slightly different viewpoints. Peering through the stereoscope's lenses blended the photographs into a three-dimensional image. Angels Flight was the subject of several stereoscope cards.

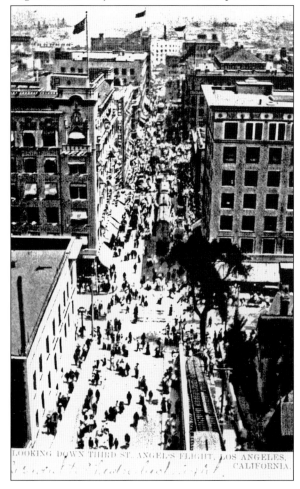

This reverse shot to the stereo card shows busy Third Street as it looked from Angels Flight's observation tower around 1906. The office building on the right, at Hill Street, was new. By now, downtown was bustling with commerce, and Bunker Hill increasingly became a place for workers to live nearby.

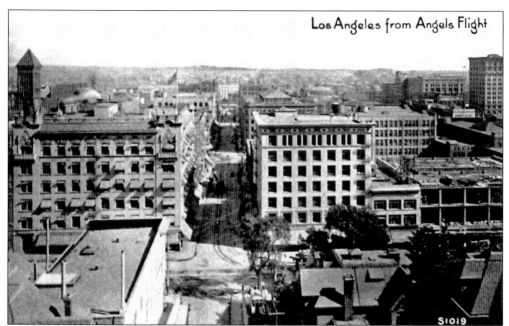

These two similar postcard views down Third Street from atop Angels Flight's tower were taken around 1907. Directly below in the left foreground of both shots is the Helena Sanitarium building. The three-story Grand Central Market building at the middle right of both photographs is under construction above and completed below. The Romanesque, pyramid-topped tower at the left of the photographs is city hall on Broadway, south of Second Street; it was demolished in 1928. The tall office building on the right edge of both photographs is the Braly Building at the southeast corner of Spring and Fourth Streets; built in 1904, it remains standing today. Another famous surviving landmark is the Bradbury Building at Third Street and Broadway, which can be seen behind the large building in the right-middle foreground.

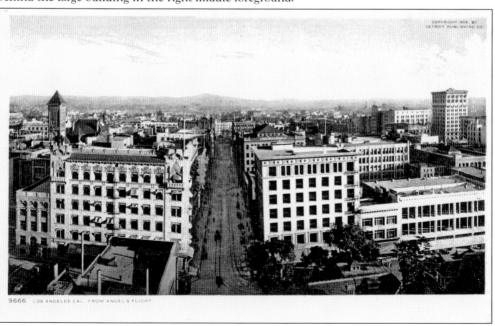

Looking down the Third Street steps from the northeast corner of Olive Street (above), the Hill Crest Inn is on the left, and farther down are the Sunshine Apartments and the St. Helena Sanitarium (later called the Fay Building). The observation tower is on the right. The shot below, taken from Olive Street north of the Hill Crest Inn, shows the tower of the City Building on Broadway framed by recently planted palm trees, which were not native to Bunker Hill—nor to Los Angeles. The building on the right is the Belmont Hotel on the west side of Hill Street.

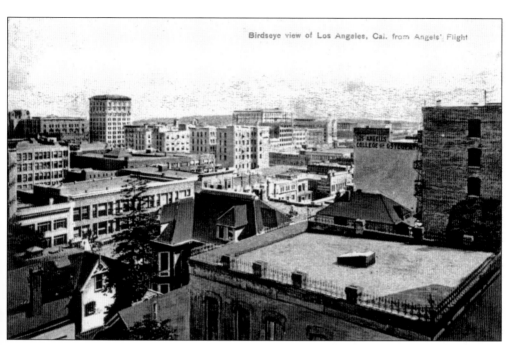

These two postcard photographs were taken from the observation tower at roughly the same time as the ones on the previous page, but these are looking southeast over the roof of the brick Nelson building at the southwest corner of Clay Street, adjacent to Angels Flight. The Braly Building at Spring and Fourth Streets (which later became the Union Trust Building and the Continental Building) dominates the skyline in both photographs. The above photograph shows that there were still a few houses on the west side of Hill Street, but clearly the commercial district was beginning to change the neighborhood's residential character.

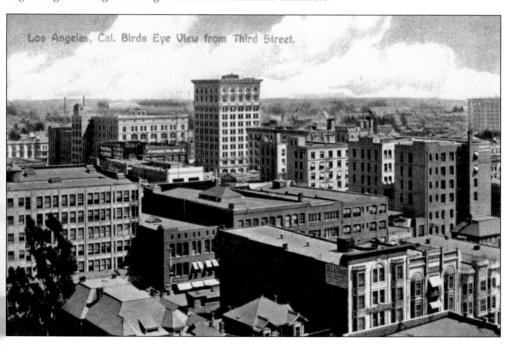

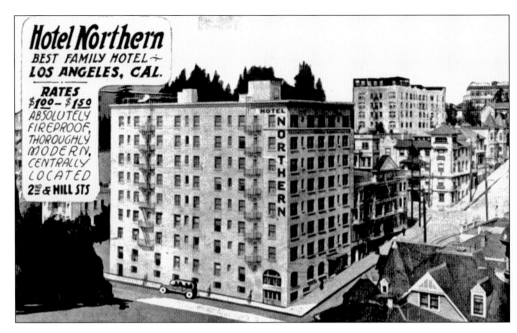

Though the Hotel Northern's heavily doctored c. 1910 postcard (above) placed its location at the "centrally located" Second and Hill Streets, it actually stood farther up the hill on the more inconvenient southwest corner of Second and Clay Streets—a block north of Angels Flight. Farther up the hill was the Mission Inn with its corner tower. The 1907 photograph of downtown Los Angeles (below) was taken from the tower of the Fremont Hotel (see opposite page) at the southwest corner of Fourth and Olive Streets—a block south of Angels Flight. Down on Hill Street at the corner are the Hotel Sherman (obscured by trees) and, next to it, the Occidental Hotel. The Braly Building is in the background.

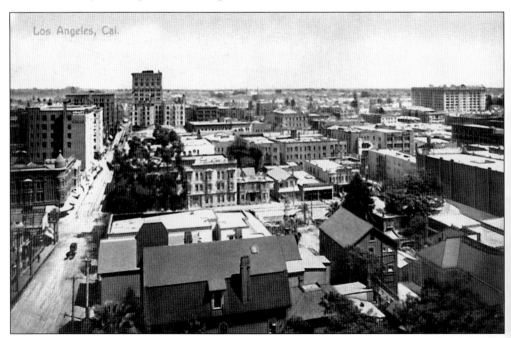

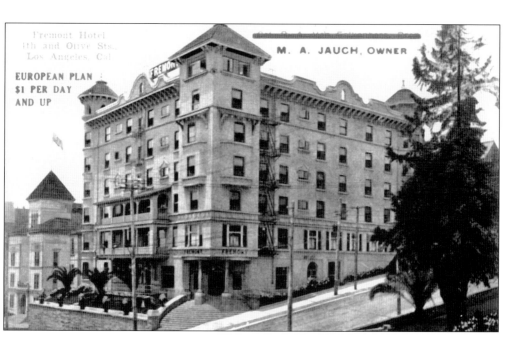

The Fremont Hotel at Fourth and Olive Streets (above) and the Trenton Hotel down the street at 427 Olive Street (below) were among dozens of hotels, apartment buildings, and rooming houses built on Bunker Hill after the start of the 20th century. The flag-flying building between them was the Olive Street Public School. Across the street from the Trenton were a set of two apartment buildings and, two lots south, the Hotel Munn. There were still a few single-family houses up and down the street, like the Ryan residence in the photograph below, but they were rapidly being torn down and replaced by apartment buildings.

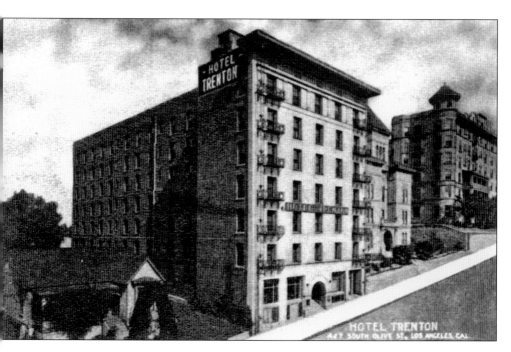

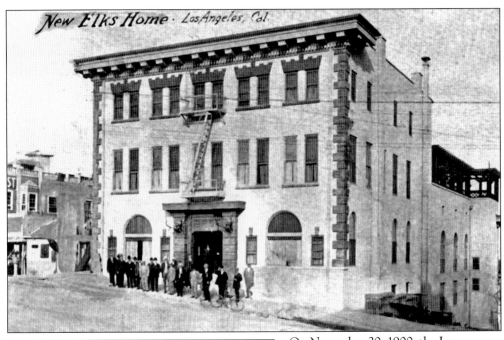

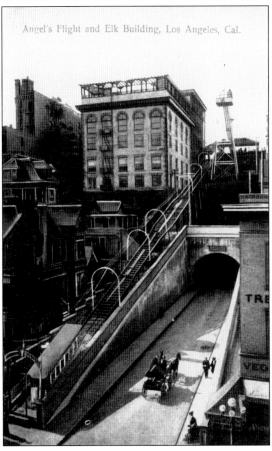

On November 20, 1900, the Los Angeles *Daily Times* noted that the wall on the north side of the Crocker mansion at the top of Third Street was "settling" because of a sinkhole caused by heavy rains. Six years later, the Benevolent and Protective Order of Elks (BPOE), a fraternal organization, bought the house for $65,000 with the idea of turning it into a new Elks' Hall, but by then, its foundations had been further destabilized by the tunnel's construction. The BPOE tore down the home in 1908 and replaced it with an Elks' Hall (above) that opened on May 6, 1909. The Nelson family erected a new building beneath it at the corner of Clay Street (left).

Now that the new, larger Nelson apartment building and the modern BPOE headquarters had been built above Clay Street, the only remaining one-family homes on this block of Third Street were the Ferguson and Benn residences (opposite page). But by 1909, William Ferguson's son, Calvin Ferguson, tore down both houses to make way for a planned office building and a residential hotel, leaving a temporary hole in an otherwise canyon of buildings on both sides of Angels Flight. The neighborhood—and Angels Flight itself—were about to make another change as they moved together into the 20th century's second decade.

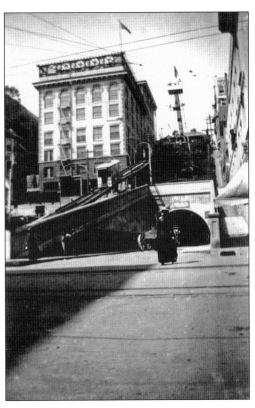

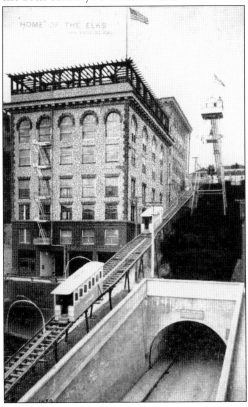

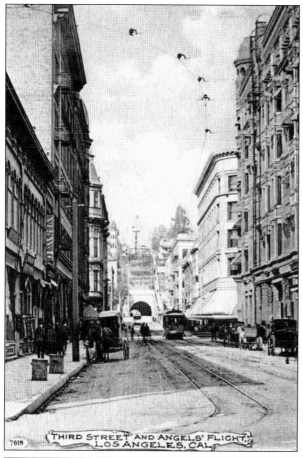

As Third Street became more commercial in the first decade of the 20th century, Angels Flight changed from a touristy neighborhood curio to a necessary transportation system for the city's casual workforce. These westward postcard views up Third Street—around 1906 (left) and 1911 (below)—document the district's increasing urbanization. By 1910, Los Angeles was a thriving metropolis, the closest thing the West Coast had to New York City—except that New York City did not have a hilltop Eden just a few blocks away, where the poor and the working class could live in 19th-century mansions with flower gardens and carriage houses.

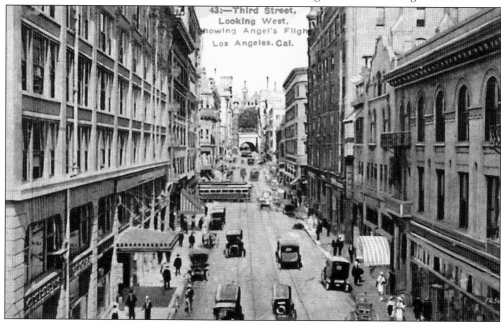

Three

A Landmark on Wheels

By 1910, as the growing commercial district of Los Angeles reached the bottom of Bunker Hill, Angels Flight was busier than ever. Dwarfed by a canyon of newly built structures like the eight-story Ferguson Building at the corner of Hill Street, the Hulburt Apartments behind it, the Nelson Building above Clay Street, the Elks' Hall at the corner of Olive Street, and the Hill Crest Inn and Sunshine Apartments on the north side of Third Street, the little Victorian railway with its pipe-sized bower archway and its metal motor house was beginning to look quaint and provincial. Angels Flight needed an overhaul, something on a grander scale. When Colonel Eddy brought in local architects Robert F. Train and Robert F. Williams, they suggested matching bookend structures at the Hill Street sidewalk and at the Olive Street summit in the oversized Beaux-Arts neoclassical style that was popular in Los Angeles at the time. (The name Beaux-Arts—pronounced *bo-zar*, French for "fine arts"—comes from the École des Beaux Arts in Paris, a school that championed combining Greek, Roman, and Renaissance architecture. The style lasted from 1885 to about 1920.) Train and Williams blueprinted the new station house as "a one-story concrete pavilion," with six arched bays broken up by plaster colonnades. At the bottom, they designed a solid arch with large Doric columns. Both structures were built by the California Ornamental Brick Company.

The architects also replaced the sunshine trolleys with wood-frame cars that looked more like railroad cars and overhauled the entire drive system with a much larger 480-volt, 50-horsepower motor (the old one was only 10 horsepower), a main cable controlled by a couple of wheels (or sheaves, as they were called), and a smaller safety cable attached to a pulley at the top. This was the new Angels Flight that would last another 59 years.

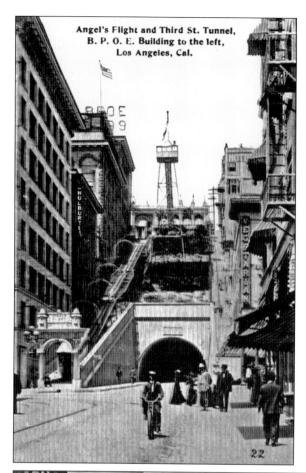

Angel's Flight and Third St. Tunnel, B. P. O. E. Building to the left, Los Angeles, Cal.

The 1910 Beaux-Arts archway and station house pavilion (seen from Hill Street in the postcard on the left) gave Angels Flight a bolder aspect to match the new buildings around it. The concrete pavilion, with four open bays (seen up close from Olive Street, below), was designed as a place to buy tickets and, according to the architects' city permit, linger and relax. The station house was also larger (filling two bays) to accommodate the railway's more powerful drive train and 50-horsepower motor, which had to be bolted down to a steel plate that in turn was bolted to the concrete floor.

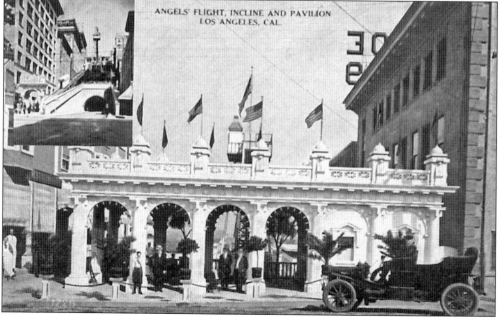

ANGELS' FLIGHT, INCLINE AND PAVILION LOS ANGELES, CAL.

In late 1912 Col. James Ward Eddy, now 80, sold Angels Flight for $80,000 in cash, stocks, and bonds to the Funding Company of California. Two years later, after being sued into bankruptcy by several people injured in an accident near the bottom of the railway, the Funding Company sold it to Robert M. Moore's Continental Securities Company. In the meantime, Colonel Eddy had retired with his second wife, Jane, to a chalet he had built at 211 West Colorado Boulevard in Eagle Rock. He died there of a stroke in 1916. Eddy was buried in his family plot (section 7, lot 220) at the Hollywood Cemetery (now Hollywood Forever) in Hollywood. (Photographs by Mary Katherine Aldin.)

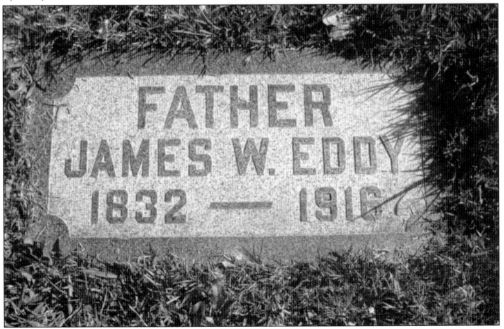

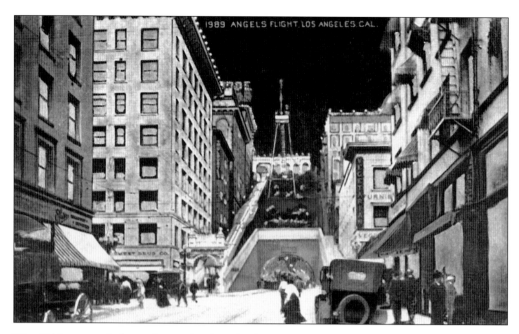

The 1912 postcard above shows the Angels Flight neighborhood still busy after the sun goes down—or does it? Actually, this is a daytime shot doctored by the printing company. (For more about "night" postcards, see page 55.) More important, this postcard and the one below were among the few in which the complete six-bay pavilion was shown intact. Because of sinkholes caused by improper backfilling during the 1901 construction of the Third Street Tunnel, the new owners had to remove the rest area at about the same time the Board of Public Works condemned the observation tower, in October 1914. The same problem had earlier doomed the Crocker mansion. Despite the edict, the tower remained standing for another 24 years.

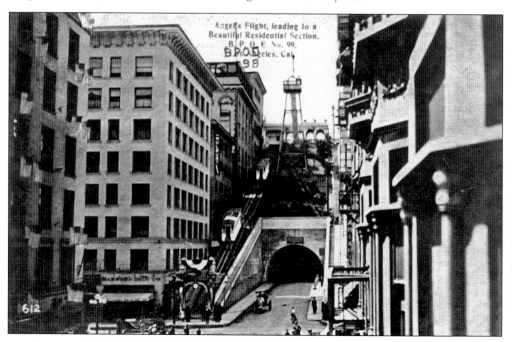

By the early 1920s, Angels Flight was an important part of Bunker Hill, providing easy access to the dozens of resident hotels, rooming houses, and apartment buildings where thousands of newly arrived workers lived. Angels Flight continued to be the subject of many postcards such as these (pictured right and below) because the majority of those workers came from somewhere else, mostly the Midwest, and liked to show the folks back home their new neighborhood and its funny little commuter train. Most of the pavilion at the top of the railway is gone, except for the bays enclosing the station house.

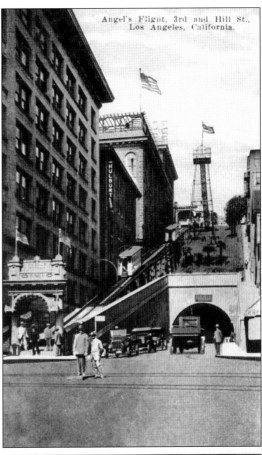

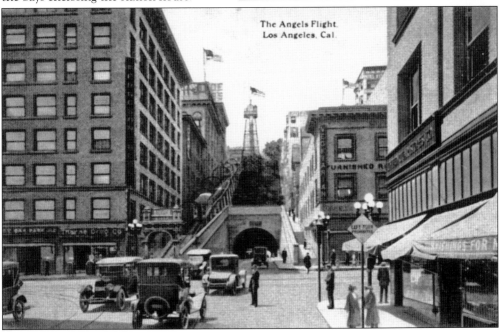

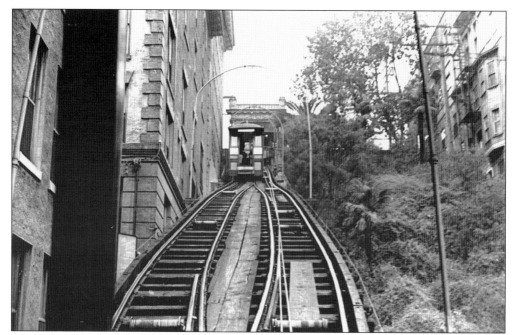

These photographs, taken from the rear of *Sinai* looking up toward *Olivet* (which always ran on the southern rail), show clearly how a three-rail funicular like Angels Flight functioned. The cars shared the middle rail on the upper and lower sections of the railway, and were able to pass each other midway, above Clay Street, when the middle rail split in two, creating a four-rail loop. These were the cars that were introduced in 1910 and remained until Angels Flight was hauled away in 1969. They were 5 feet wide and 24 feet long, and sat 38 passengers each. (Both, Bison Archives.)

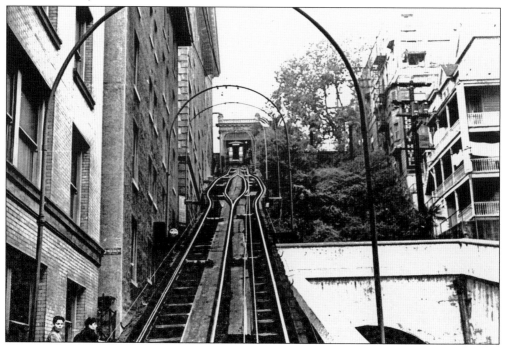

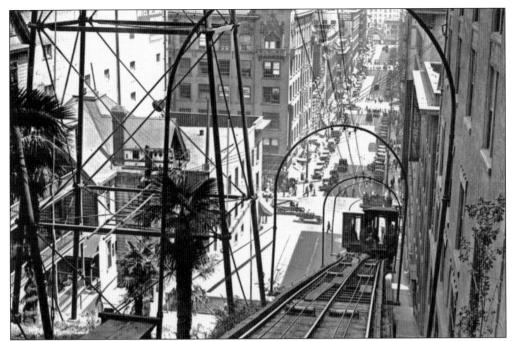

Robert M. Moore, Angels Flight's owner from 1914 to 1952, presided over the railway's most prosperous years. To insure passengers' safety, the station house operator inspected the 444-foot-long main cable and the 340-foot-long safety cable every morning, and the company engineer inspected them every month. The main cable was changed once a year. The 1928 photographs on this page show the graceful movement of the cars as they pass each other above Clay Street and approach their destinations. The multilevel porches of the Sunshine Apartments and the McCoy house are visible through the struts of the observation tower. (Both, Bison Archives.)

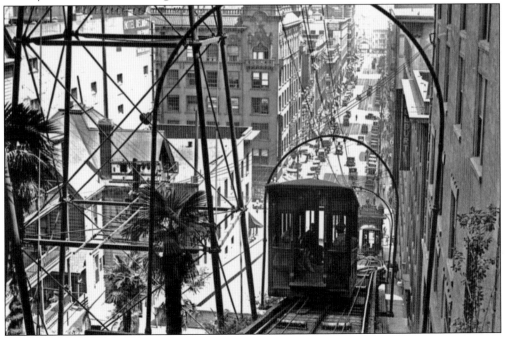

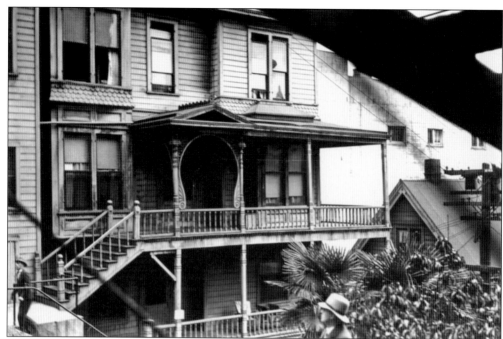

The Sunshine Apartments at 425 Third Street, seen here from the stairway on the south side of Third Street beneath the tracks (above) and from Clay Street (below), was a familiar part of the Angels Flight tableau. It was built around 1905, combining clapboard farmhouse architecture with Queen Anne elements. Perched atop a concrete wall at the northwest corner of Clay Street and the Third Street steps, the Sunshine—with its extravagant verandas and its labyrinth of hallways and staircases—became a common postwar Hollywood shooting location after making its debut in the 1932 Universal film *The Impatient Maiden*. (Both, Bison Archives.)

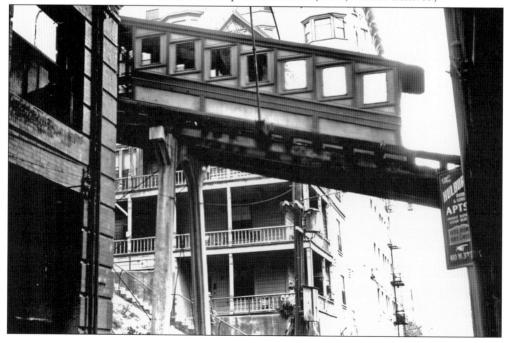

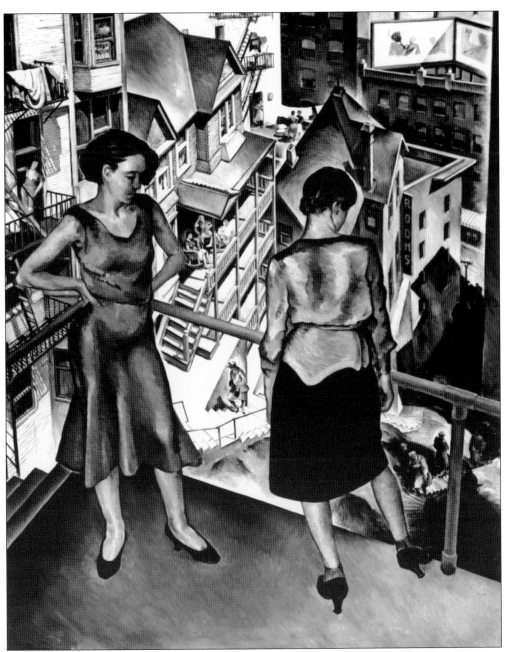

Millard Sheets (1907–1989) was a Southern California artist who worked in a style called American Scene, a refinement of the Ash Can School that celebrated the lives of ordinary people. Though known primarily today for his watercolors and public murals, Sheets painted his most famous work in oils: *Angel's Flight* (1931), a tableau of two "angels of the tenements" relaxing at the edge of the Olive Street station's pavilion deck. The railway itself is nowhere to be seen, but prominent in the background are the Hillcrest Hotel, the Sunshine Apartments, the McCoy house, and the Fay Building on the corner of Hill Street. Sheets's *Angel's Flight*, painted in vibrant pastels and measuring slightly more than 4 feet high, is on permanent display at the Los Angeles County Museum of Art (LACMA). (LACMA, a gift of Mrs. L. M. Maitland.)

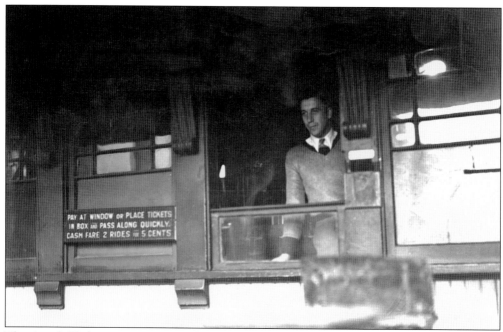

The Angels Flight station master at the top of Angels Flight (seen above in the 1920s) collected the fares of upward-bound passengers as they got off, loaded passengers onto the trolley going down, and hand-operated both cars. He had little control of passengers getting on at the Hill Street entrance, other than activating (with a button) a red light, a Klaxon, and an electric turnstile that held latecomers back after the car started moving. The station house (seen in 1946, below) looked more utilitarian after the pavilion was removed. The stairway (left, behind the woman) led to the park below the station where the observation tower had stood until 1938. (Both, Bison Archives.)

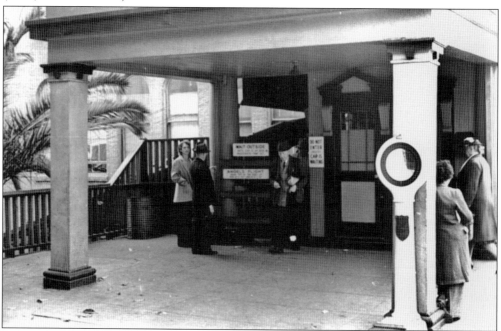

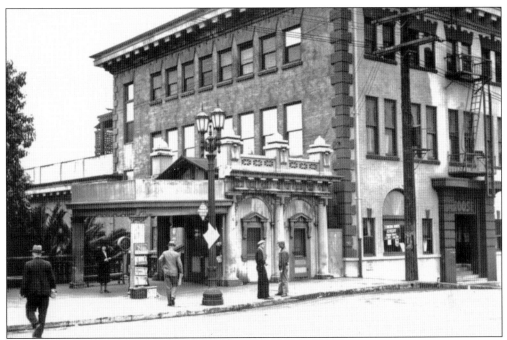

"We Angels Flight commuters have our busy depot, the upper terminal plaza at Olive and Third Sts., complete with an old but reliable scale, three phone booths and a [drinking] fountain. Like commuters on the El in Chicago, some of us funicular folks feed pigeons while we wait (never more than a minute) for our train," wrote Charles Hillinger in the *Los Angeles Times* in 1958. The Angels Flight station was one of Bunker Hill's most popular hangouts. The former Elks' Hall at the right had been converted into the Royal Apartments by the time these photographs were taken in the 1940s. (Both, Bison Archives.)

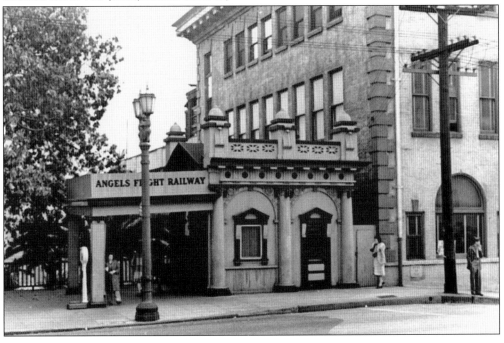

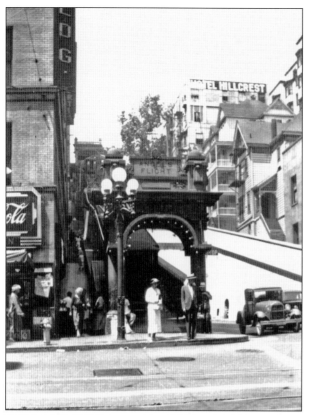

"You board your car and sit on one of the narrow, hard wooden benches which terrace the car's interior," Donald Duke wrote in 1958. "A warning buzzer sounds telling that the car is ready to ascend. Suddenly you're off and up a 33% grade. . . . The hustle and bustle of vehicular traffic drop away as you climb. If you happen to look uphill you see the car's twin bearing down the same track and the two cars slip by each other with scarcely enough room to pass. A few seconds later you're at the end of the line, Third and Olive streets. You and your fellow passengers file past a ticket window and give the man a nickel." (Both, Bison Archives.)

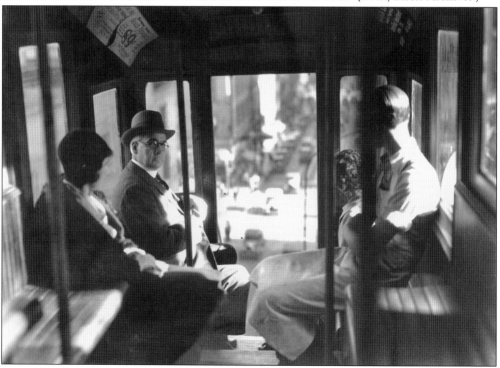

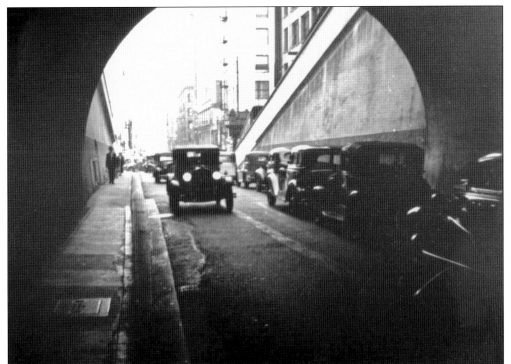

From the day it opened in 1901, the Third Street Tunnel (seen above looking east in the 1930s) was the most efficient conduit from the downtown side of Bunker Hill to Hope Street on the western side—and remains so even today. Along with the Second Street Tunnel a block north, the Third Street Tunnel is all that survives from the original Bunker Hill. Pictured right, (from left to right) Pat Crawley, assistant shop foreman George Walter, and Angels Flight superintendent Edward C. Spenzeman peek through the spokes of a cable wheel in a 1951 *Los Angeles Examiner* photograph. (Both, University of Southern California, Special Collections.)

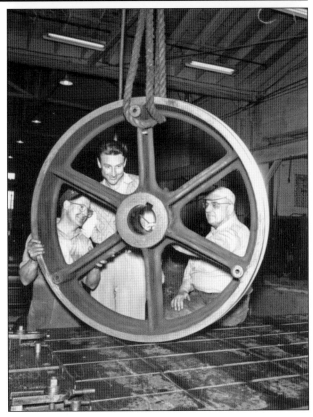

Beverly Hills Parlor, Native Daughters of the Golden West, cordially invites you and your friends to be present at the marking of historical Angels Flight at Third and Grand Avenue, Los Angeles, California, November 18, 1952, at 11 a.m.

THE PROGRAM

WELCOME—Mrs. Gerald Thomas, President, Beverly Hills Parlor #289 N.D.G.W.

PRESENTATION, Chairman of the Day—Mrs. Francis Sullivan, History and Landmark chairman, Beverly Hills Parlor # 289. Grand Organist, Native Daughters of the Golden West

FLAG ESCORT—Westwood Cub Scout Pack #55

PLEDGE OF ALLEGIANCE TO OUR FLAG—Mrs. C. Dwight Bradley, Co-Chairman, History and Landmarks Committee

INVOCATION—Most Reverend Joseph T. McGucken

GREETINGS—Hon. Fletcher Bowron, Mayor of Los Angeles

INTRODUCTION, Master of Ceremonies—Eugene Biscailuz, Sheriff of Los Angeles County

HISTORY OF "THE ANGELS' FLIGHT"
INTRODUCTION, Mr. Eddy Gillette, grandson of Col. J. W. Eddy, builder of Angels' Flight

REMARKS—Mr. Walter Bowers, Asst. Attorney General of California

MEMORIES—Mary Foy, Pioneer Los Angeles Resident

PRESENTATION of City and County Officials

INTRODUCTION OF DISTINGUISHED GUESTS

INTRODUCTION, GRAND OFFICERS, Native Daughters of the Golden West, Mrs. Frank Blosdale, Past Pres., Beverly Hills Parlor #289

REPRESENTING N.D.G.W.—Mrs. Leiland Atherton Irish, member of Californiana Parlor #247

REPRESENTING N.S.G.W.—Mr. Elrded Myer, Past Grand Pres., N.S.G.W.

INTRODUCTION OF GRAND OFFICERS, N.S.G.W.

PRESENTATION AND UNVEILING OF PLAQUE—Mayor Fletcher Bowron, Sheriff Biscailuz, Mrs. Francis Sullivan

ACCEPTANCE OF PLAQUE—Mr. Lester B. Moreland and Mr. Byron E. Linville, owners of "The Angels' Flight"

MUSIC—Jose Nieto and his serenaders. Courtesy of A.F. of M. music performance trust fund, Local 47. Arranged by the Los Angeles Bureau of Music.

On August 23, 1952, less than six months before his death, Robert Moore sold Angels Flight to electrical engineer Lester B. Moreland. Moreland's wife, Helen, arranged for the Beverly Hills branch of the Native Daughters of the Golden West, a historical organization, to honor Angels Flight with a bronze plaque near the station house commemorating its first half century. The city mayor and the county sheriff presided over the ceremonies, and Colonel Eddy's grandson, Simeon Eddy Gillette, attended. (He died a month later and was buried at the Eddy plot in Hollywood.) Below is the Morelands' 1953 Christmas card. (Both, Eagle Rock Valley Historical Society.)

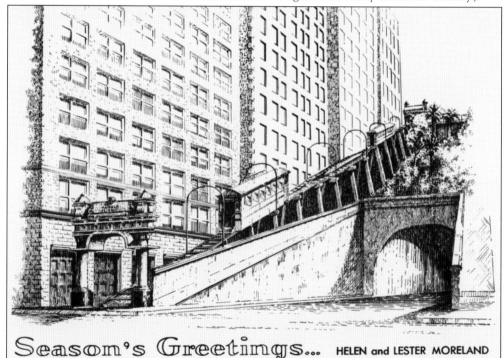

Season's Greetings... HELEN and LESTER MORELAND

Four

Postcard Perfect

The opening of Angels Flight on December 31, 1901, came only a week after the U.S. Post Office authorized the "post card" on December 24 and thereby created the American picture postcard industry. Printing companies were immediately attracted to the photogenic railway that rose up to the Victorian mansions like a robber baron's extravagant dumbwaiter. It was just the sort of quirky attraction that visitors, especially the new breed of casual travelers called tourists, loved to send back home. Within a year or so, Angels Flight became a Los Angeles landmark.

The post office required that cards be one standard size (3.5-by-5.5 inches), and the backside could be used only to write a name and address, and affix the 1¢ stamp required to get the card to its American destination. (Foreign postage was 2¢.) Since personal messages had to be jotted on the front, printers left a wide border around part of the photograph to accommodate a few words.

On March 1, 1907, the U.S. Post Office authorized the new "divided-back" postcard that allowed senders to write their messages on the back, to the left of the name and address. Collectors call the "divided-back era" (1907–1915) the golden age of postcards. German printers, considered among the best lithographers, opened offices in the United States and boosted postcard sales into astronomical numbers. The post office claimed that from mid-1907 to mid-1908, when the U.S. population was less than 89 million people, it handled nearly 678 million postcards.

Unfortunately, German printers were cut off from the U.S. market after World War I broke out in August 1914. The poorer quality of American and British postcards, along with war shortages and an influenza pandemic that kept people close to home, ended America's postcard craze.

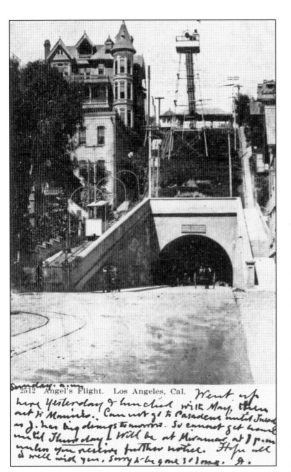

This early black-and-white postcard, printed by Oscar Newman Publishing in Los Angeles, was mailed to Montecito, California, in 1906. It shows the original Angels Flight before Colonel Eddy replaced the open-air trolleys with enclosed cars and raised the tracks the previous year. The card's sender noted at the bottom: "Went up here yesterday and lunched with May." This area of the card was left open for jotting messages because the reverse side (below) was designed strictly for writing the recipient's address, in accordance with postal regulations. Handwriting on the face of early postcards does not devalue them among collectors.

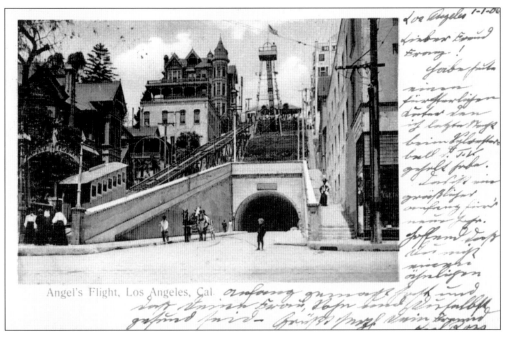

Angel's Flight, Los Angeles, Cal.

This hand-painted Angels Flight postcard from M. Rieder Publishing in Los Angeles (above) provided space below and to the right of the photograph for a hand-written message. What postcard collectors now call the "undivided-back postcard era" lasted from 1901 to early 1907, when a change in postal regulations allowed messages to be written on the back. That led to the divided-back postcard like the one below—printed by the Newman Post Card Company and mailed to Philadelphia in 1908—which has the same photograph of Angels Flight as above but blown up to the card's full size. The photograph was taken after the tracks were elevated in 1905.

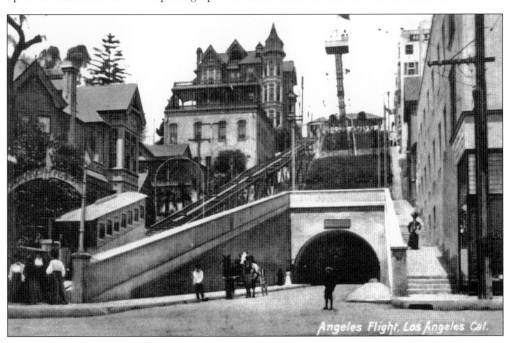

Angeles Flight, Los Angeles Cal.

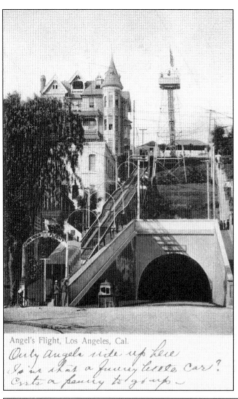

Sometimes a giddy tourist's on-the-spot remarks could outdo even the most loquacious travelogue writer. At the bottom of this 1905 undivided-back, M. Rieder postcard, a peregrinating poet's handwritten comments say it all: "Only angels ride up here. Isn't that a funny little car? Costs only a penny to go up."

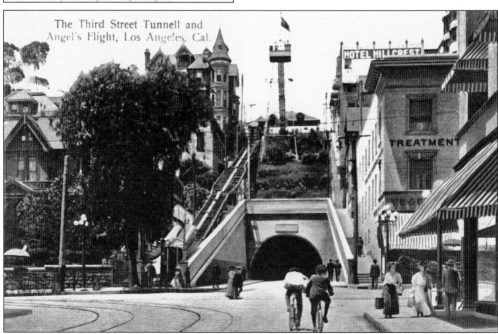

Postcard companies often updated or changed photographs from one edition to the next. Here is an example (above) of a photograph of Angels Flight taken around 1907 and published by M. Rieder. (Note the misspelling of the Third Street "Tunnell," probably by the German printer.) Compare it with the postcards on the opposite page.

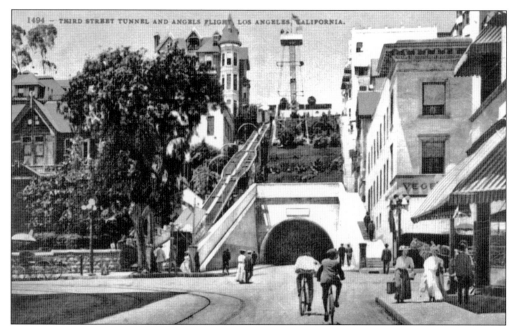

Publisher Edward H. Mitchell reprinted the same picture but altered several details: The words "Hotel Hillcrest" and "Treatment" have been removed from the buildings on the right; telephone poles and wires are gone; an extra human figure stands on the Third Street stairway; and a grassy area has been added to the lower left corner.

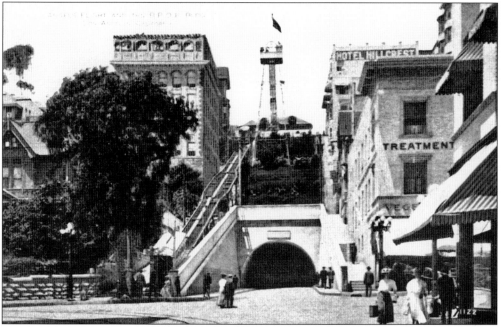

Now look at a later (1908) postcard with the same photograph, printed by the Benhan Indian Trading Company: The buggy near the lower left corner is gone, and so are the cyclists; but the most obvious change is that the Crocker mansion is hidden by the imposition of an oversized photograph of the new Nelson building.

53

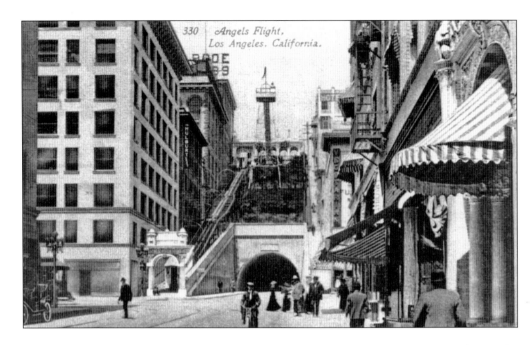

Probably the greatest change in American society during the golden age of postcards was the obsolescence of horse-drawn wagons and buggies as the so-called horseless carriage, or automobile, replaced them. The original Edward H. Mitchell card (above) was shot and printed around 1910–1912, showing a quiet view of Third and Hill Streets, with a bicyclist, a trolley passing out of sight, and an early automobile parked on the left. But when the Western Publishing and Novelty Company in Los Angeles reissued the card a couple of years later (below), it updated the photograph by dropping a sporty roadster into the foreground.

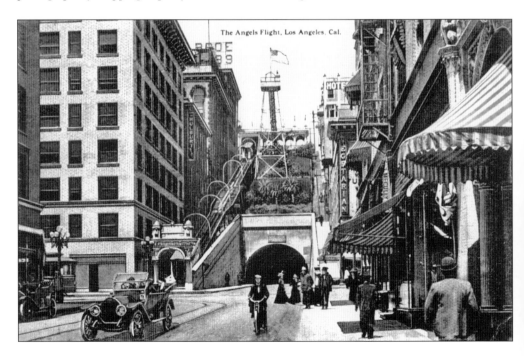

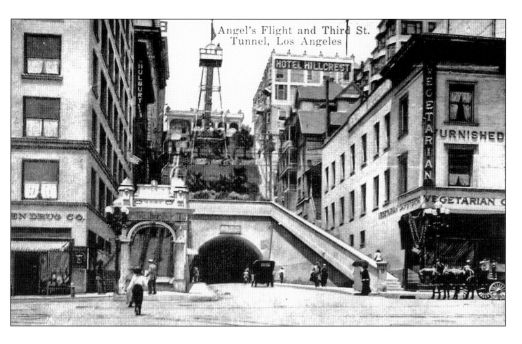

Postcard printers routinely turned day into night for an exotic effect. For example, the M. Kashower and Company printed a card (above) showing Angels Flight as it looked on a sunny day between 1910 and 1914. Then the H-H-T Company reissued the photograph as a nightscape, with silhouettes added to glowing windows (below). The printing on the back reads: "The Angels' [sic] Flight is a unique traction enterprise that connects the business section of the city with the hill section, where are located the apartments and rooming houses. The incline is 40 per cent [sic] and is a counterbalanced two-car operation."

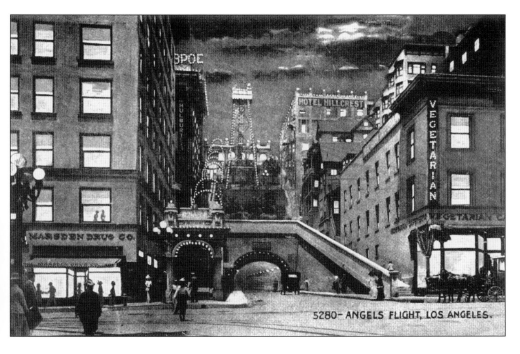

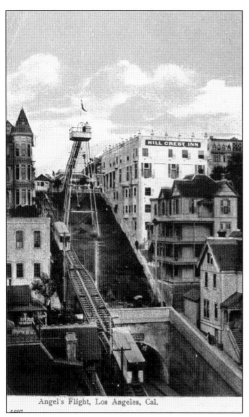

Angel's Flight, Los Angeles, Cal.

Printers added clouds to the skies of postcard scenes and sometimes changed their design from one edition to another. For example, the Newman Post Card Company offered this early aerial photograph (taken from a nearby building) with several different cloud formations. Nowadays, each cloud edition of this series has a different value among collectors, depending on how many were printed. Note the rare peek down upon the rooftops of the Ferguson and Benn houses in the lower left corners, as well as the straight-on view of what were then the new Hill Crest Inn and the Sunshine Apartments beneath it.

Angels Flight, Los Angeles, Cal.

56

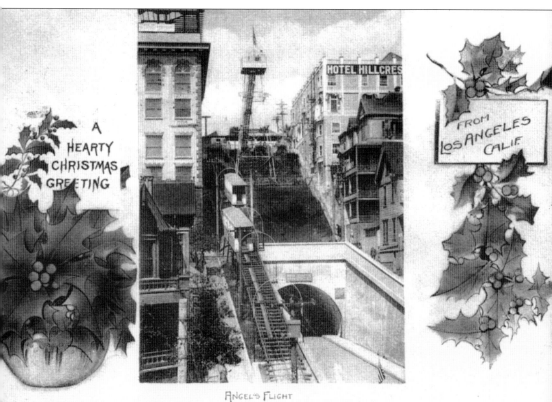

Seasonal postcards were favorites then as they are today. San Francisco–based Richard Behrendt printed this Angels Flight Christmas postcard around 1908. It was mailed in 1910 from the town of Sierra Madre (northeast of Los Angeles) to Nellie Sleever in tiny Stromsburg, Nebraska, who no doubt found the funicular and the four-story house (the Sunshine Apartments) with three porches very exotic. The message on the back of the card had a poignancy one might expect during the Christmas season: "We are one less this year as we laid to rest one of my sisters. We have one left + we are with her at Sierra Madre [and] have been for about three months. We're about the same, but hope the New Year will find us settled in [a] home of our own. Are you all at home. Lovingly, Ella."

Vintage postcard collecting has been a widespread hobby and lucrative business for decades. In the 1970s, after Angels Flight was removed from Bunker Hill and put into mothballs, a collector ran an Angel's Flight Post Card Club from an Appleton Street apartment in Long Beach, California. Members met on the fourth Monday of each month. The club issued several commemorative postcards, including a watercolor by E. Marquez (left) and an early photograph in which a trolley was replaced with a rocket taken from French film pioneer Georges Melies's 1902 fantasy, *A Trip to the Moon* (below). The club disbanded many years ago.

Five
"Funiculì, Funiculà"

The official name of Colonel Eddy's enterprise on the eastern slope of Bunker Hill was the Los Angeles Electric Incline Rail Road or, as the sign atop the cars put it, "L.A. Electric Incline R.R." But almost from opening day, people simply called it Angels Flight. Nobody called it a funicular, though that is what Angels Flight was.

Though "incline railway" is the preferred American term, funicular—from the Latin *funiculus*, or rope—is more commonly used around the world. A funicular is a cross between an elevator and a railway. Two counterbalanced cars move up and down a steep grade, each attached to a cable or a cog controlled by a motorized pulley at the top. Since one car is always descending, it helps pull the other one up the hill. At the same time, the ascending car keeps its mate from speeding out of control. The funicular's motor system needs only to compensate for the difference in the weight of passengers between cars and to overcome natural friction.

But Angels Flight was a modified version of traditional funiculars. Each car had its own cable instead of being attached to a single cable loop. And rather than two separate sets of tracks, the cars basically shared the same rails at the top and bottom of the incline and passed within a few inches of each other on bow-shaped, four-rail side tracks in the middle.

Primitive funiculars have been around in one form or another since the 15th century, mostly in the mountainous areas of Europe. The modern incline railway was developed by British coal-mining engineers in the early 1700s. The first American operation was built in Pittsburgh, Pennsylvania, in 1870.

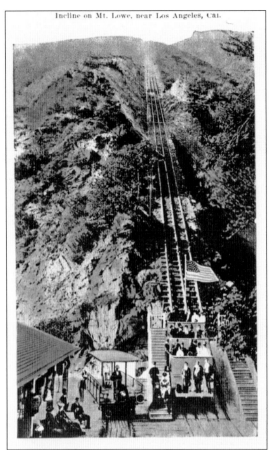

Colonel Eddy found his inspiration for Angels Flight in the hills above Altadena, northeast of Los Angeles, where eight years earlier Thaddeus Lowe had constructed a precipitous 3,000-foot "Railway in the Clouds" on Mount Echo to reach a hotel he built at the summit. One segment was so rugged that Lowe abandoned the idea of continuing his railroad because the anchoring and backfilling would have been too expensive. Instead he built a connecting three-rail funicular—called the Great Incline—with a fourth passing rail at the midpoint. Bunker Hill did not present Colonel Eddy with Mount Echo's topographical challenges, but he thought that Lowe's railway looked more elegant and less industrial than other funiculars he had seen.

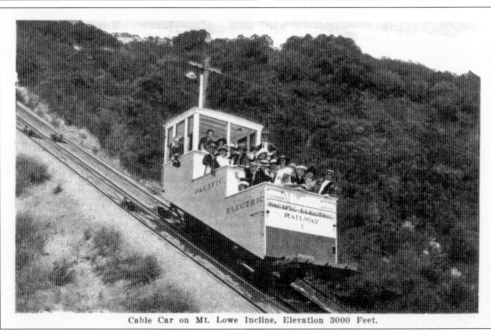

Thaddeus Lowe's cars, named *Rubio* (for the canyon where the railroad began) and *Echo*, picked up passengers from a transfer station and ferried them 1,300 feet straight up the mountainside. The sudden climb eliminated more than a mile of what would have been winding railroad tracks. By the time Colonel Eddy built Angels Flight in 1901, Lowe had already sold his mountain railway, but it carried on for another 36 years. Eventually, fire destroyed the mountaintop hotel and several other buildings, and both the Railway in the Clouds and the Great Incline fell into disrepair. The operation ended in 1937. Mount Echo had by then been renamed Mount Lowe.

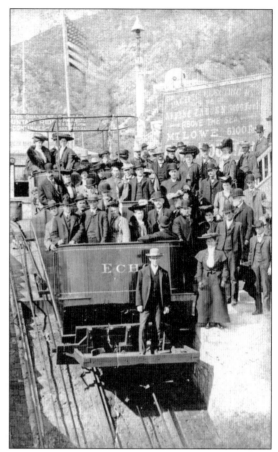

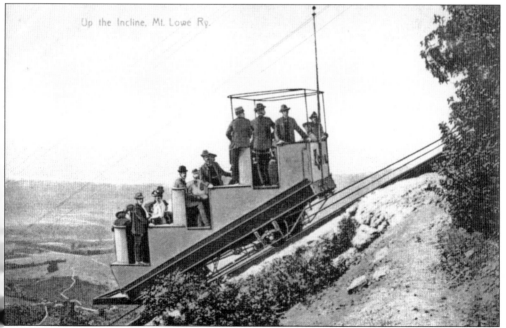

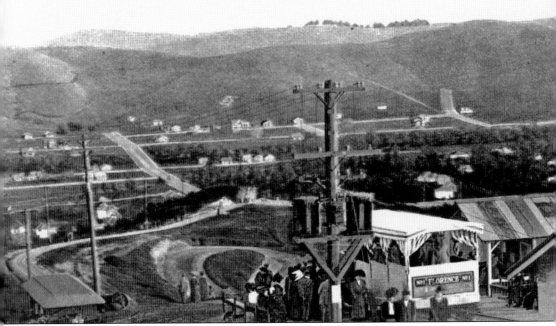

2365 – VIEW FROM TOP OF INCLINE, LOS ANGELES AND MT. WASHINGTON RAILWAY, LOS ANGELES, CALIFORNIA.

Seven years after Angels Flight opened, Robert Marsh built a residential subdivision on Mount Washington, a few miles north of downtown Los Angeles, and advertised it as "A Real Mountain, With Real Mountain Views." To make it accessible, he built the 3,000-foot Los Angeles and Mount Washington Railway, which opened on May 24, 1909. Two cars, *Florence* and *Virginia*, ran on an endless cable in the middle of what later became Avenue 43, starting at a station on Marmion Way and ending at a summit hotel. Like the other Los Angeles inclines, it used three rails with a midway four-rail turnout, where the conductor stepped from the ascending to the descending car. The fare was 5¢ each way. The line ran from 6:00 a.m. to midnight. Marsh closed the Mount Washington incline on January 9, 1919, after a dispute with Los Angeles's Board of Public Utilities about upgrades and repairs. The Marmion Way station is now a residence; the powerhouse and the former hotel are in private hands.

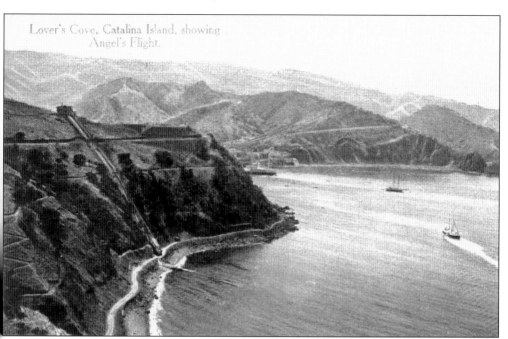

Lover's Cove, Catalina Island, showing Angel's Flight.

Bunker Hill's Angels Flight also shared its name with an obscure railway on Santa Catalina Island, two dozen miles offshore from Long Beach, California. This Angel's Flight was half of what was called the Island Incline Railway, built by the Banning brothers in 1904. The other half, billed as the Mountain Railway, carried passengers from an amphitheater on the southern edge of the leeward tourist town of Avalon to the scenic top of a mountain, where they could stay at an inn or take the other half—Angel's Flight—down the mountain's ocean side to Pebble Beach's Lovers' Cove. By all accounts, it was a spectacular ride. The owners suspended the railway in 1918. It reopened for a couple of years in the early 1920s before being scrapped for good. Nothing remains today.

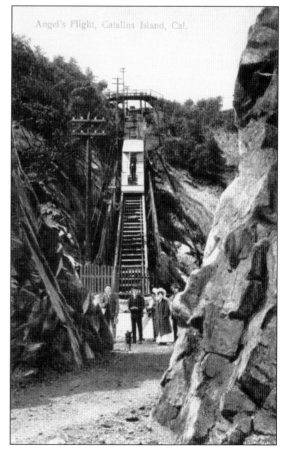

Angel's Flight, Catalina Island, Cal.

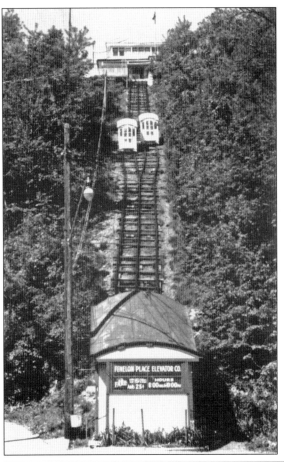

Though Colonel Eddy hailed Angels Flight as the world's shortest railway, that honor belonged to the Fenelon Place Elevator (left) in Dubuque, Iowa. The Fenelon was, and still is, not just the world's shortest public funicular but the steepest, rising 189 feet on only 296 feet of track on its way from Fourth Street to scenic Fenelon Place. Built in 1893 after fire destroyed two previous one-car elevators, the Fenelon Place Elevator, also called the Fourth Street Lift, runs on a set of three rails with a fourth-rail bypass. Another railway that may have been shorter than Eddy's Angels Flight was (another) Angel's Flight (below), which Arthur Fowle opened in August 1909 near Lake Macatawa in Michigan to ferry nearby resort hotel guests to a dance pavilion atop Old Baldhead. This Angel's Flight closed down in 1922.

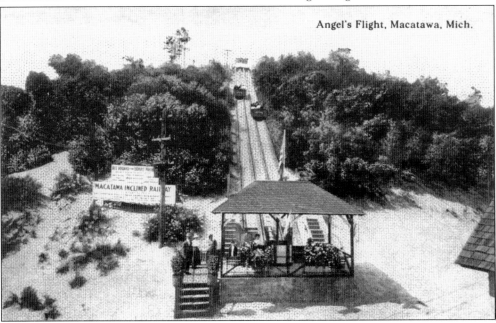

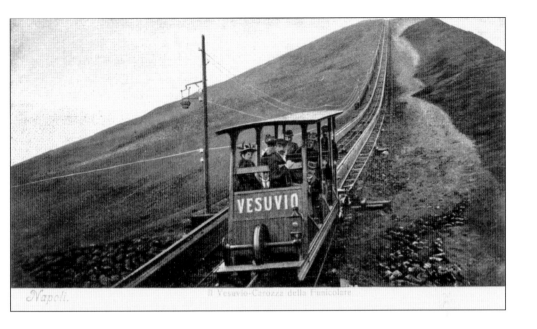

Perhaps the world's most famous funicular cars—*Etna* and *Vesuvio*—carried tourists and hikers up the side of Mount Vesuvius, the volcano outside of Naples, Italy, that buried Pompeii nearly 2,000 years ago. To commemorate the railway's opening in 1880, its owners commissioned a Neapolitan composer named Luigi Denza, along with journalist Giuseppe Turco, to write a tarantella-cum-advertising jingle called "Funiculì, Funiculà." The song became so popular that, even today, it is a staple of nearly every Italian American nightclub act. The funicular, on the other hand, was not so lucky. Mount Vesuvius put an explosive end to it in 1944.

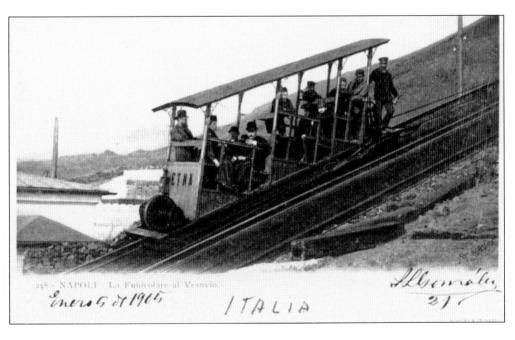

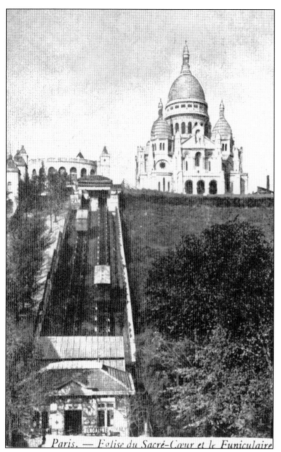

Paris. — Église du Sacré-Cœur et le Funiculaire

Today there are more than 100 public funiculars around the world, from Tiflis, Georgia, to Chattanooga, Tennessee. One of the busiest (left) is a 340-foot railway with separate tracks below the Basilica of the Sacred Heart at the summit of Montmartre, the highest hill in Paris. And one of the most remarkably built is the 3,609-foot-long Pic du Jer Funicular (below) that links the French Pyrenees town of Lourdes with the scenic summit of nearby Pic du Jer. Each car accommodates 80 passengers and takes 15 minutes to climb to the top. Though both funiculars are more than 100 years old, they remain viable and popular. Who knows? The future may have an even greater need for fuel-efficient incline railways.

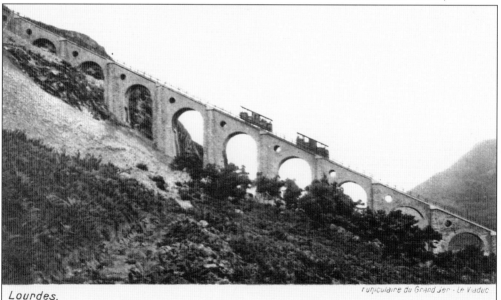

Lourdes. — Funiculaire du Grand Jer - Le Viaduc

Six

COURT FLIGHT

Angels Flight was a Los Angeles celebrity almost from the day of its opening, but three blocks north, in Bunker Hill's Court Hill neighborhood, it had a less-glamorous sister called Court Flight. Built by Samuel G. Vandegrift in 1904, Court Flight ascended 335 feet from North Broadway between Temple and First Streets to the dead-end of Court Street (formerly Court House Street), just below mining magnate Lewis Bradbury's mansion on Hill Street. With its 46-percent grade, Court Flight was a dozen degrees steeper than Angels Flight. Like traditional funiculars, its two cars ran on parallel tracks. In accordance with the same city regulations that earlier guided the construction of Angels Flight, Vandegrift built an adjacent stairway (140 steps with a landing one-third of the way up) and charged passengers (one nickel) only for uphill trips.

Court Flight never had much tourist appeal. Its commercial advantage was its proximity to the city's civic center. Directly across Broadway was the Los Angeles County Hall of Records, next door to the Los Angeles County Courthouse at the corner of Temple Street. By the 1920s, commuters could park at the cheap lots near the top of the hill and ride down; at lunchtime city administrators, judges, and other functionaries rode up to a well-appointed restaurant in the Bradbury mansion until it was torn down in 1929.

Vandegrift single-handedly ran his railway until his death in 1932. His widow, Annie, carried on, but by 1942, financial problems forced her to appeal to the Board of Public Utilities to let her abandon her city contract. On September 19, 1943, fire damaged the wooden ties, and Court Flight never reopened. The tracks and cars were hauled away in 1944. Eleven years later, when construction for the Santa Ana Freeway sliced through the area, Court Hill—the mansions, the north-south Hill Street Tunnel beneath it, and the hillside where Sam Vandegrift once plied his trade—disappeared completely. Annie Vandegrift died in 1967.

These early-1890 photographs, taken from the county courthouse, show the Court Street cul-de-sac at the top of Court Hill 14 years before construction began on Court Flight. The mansion in the middle of the picture above is the Lewis Bradbury home at Court and Hill Streets. (He built the famous Bradbury Building a few blocks away, at Third Street and Broadway.) The photograph below gives a wider picture of Broadway (diagonal at lower left) and Hill Street (ascending the hill from the left as it approaches the Bradbury home at right). The distinctive Crocker mansion is visible on the ridgeline in the distance. (Above, Andrew M. Schwartz; below, Bison Archives.)

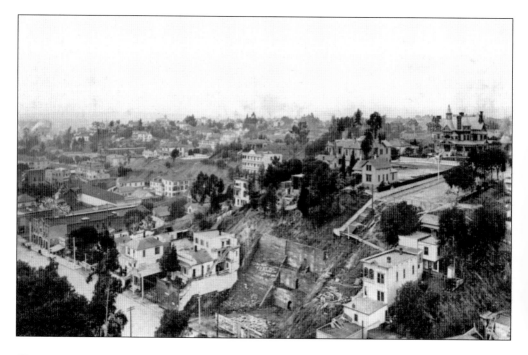

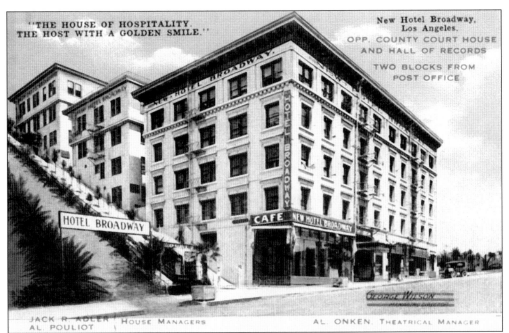

Court Flight opened in 1904 next to the new 350-room Hotel Broadway at 208 North Broadway, just south of Temple Street. The hotel boasted "comfort without extravagance on the Great Broadway," though the main shopping district was several blocks away. The hotel's main draw was Los Angeles County's civic center across the street.

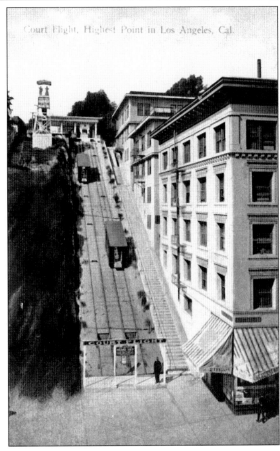

Vandegrift constructed the "One Big Look" tower at the top of Court Flight (seen here in 1908) to match Colonel Eddy's 100-foot tower three blocks away. A sign at the bottom read: "Take this car for the highest point in this city from which the finest view of the city, mountains, and the islands of the ocean can be had."

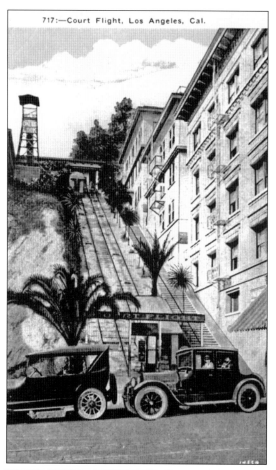

In the 1920s and 1930s, Court Flight ferried 1,000 passengers a day up and down Court Hill, but few were tourists looking for a scenic panorama from the One Big Look tower. The railway mostly served the civic center across the street. The tower was torn down in the 1930s.

Los Angeles's 10-story Hall of Records (above, at right) stood directly opposite Court Flight on the east side of Broadway, next to the sandstone Los Angeles County Courthouse. By the 1920s, Court Flight was thriving because many of the houses atop Court Hill had been replaced by parking lots to accommodate the city's increasing automobile traffic.

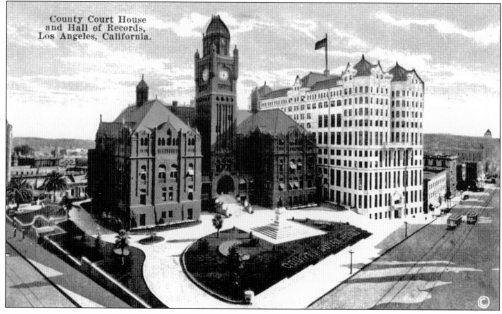

Novelist Raymond Chandler did not give Court Flight much respect. In his 1942 novel *The High Window*, private detective Phillip Marlowe conflated Court Flight with Angels Flight: "I parked at the end of the street, where the funicular railway comes struggling up the yellow clay bank from Hill Street [sic], and walked along Court Street to the Florence Apartments." (Bison Archives.)

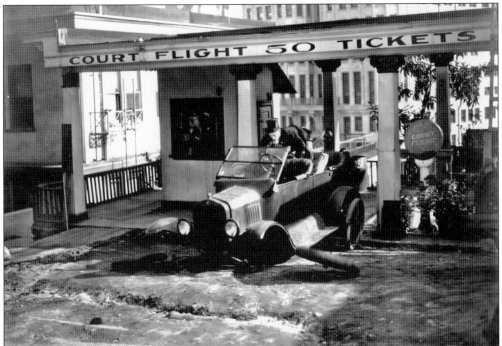

When the Roach-Linthicum Studio opened an office in the Bradbury mansion in 1915, it shot many movies on Court Hill with Harold Lloyd, Charlie Chaplin, and other silent film performers. In this 1928 photograph, slapstick roustabout Jack Duffy, who starred in many Christie Studio comedies, did a gag at the top of Court Flight in *Say Uncle*. (Bison Archives.)

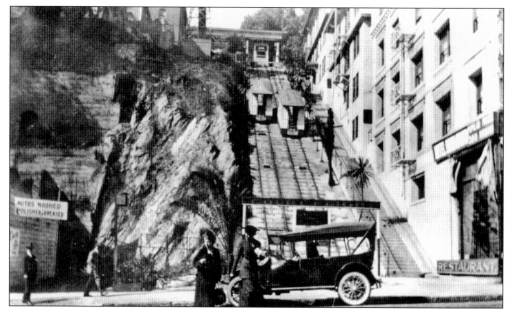

An unknown Harold Lloyd shot a 1915 one-reel "Willie Work" comedy on Court Flight. "We had a funicular, one of these very steep things," Lloyd said in 1959. "The cameraman had shot it from the top, shot straight down, and when we went into the projection room to look at it, it looked like I was rolling on a sidewalk." The film was later lost. (Security Pacific Collection/LAPL.)

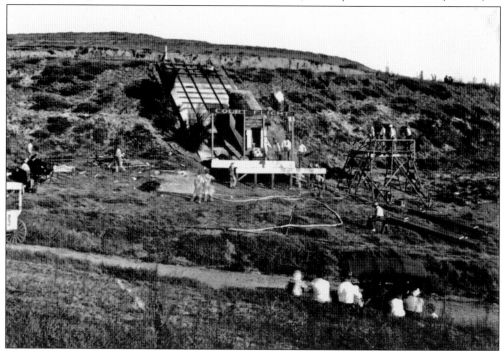

In this 1915 photograph, an early Long Beach studio called Balboa Amusement Producing Company built a mock-up of Court Flight on nearby Signal Hill for an unidentified movie that is likely one of the 80 percent of all pre-1929 silent films that no longer exist. The Balboa studio made hundreds of movies before it folded in 1923. (Robert S. Birchard.)

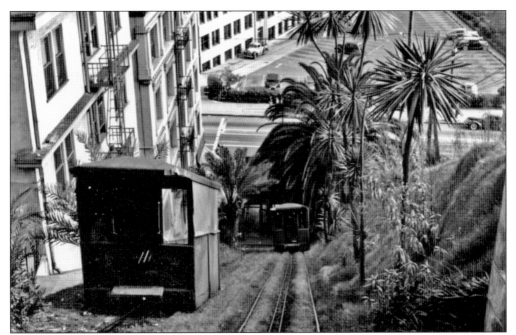

This 1940 photograph looks down Court Flight toward the Hall of Records. The large building was off-angled because it had been built along a short street that was later torn up. Court Flight soon closed down because of war-related shortages and never reopened. (Photograph by Ansel Adams; Security Pacific Collection/LAPL.)

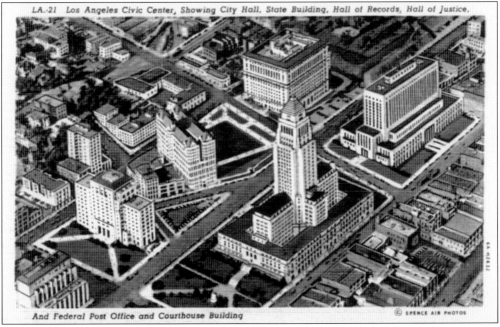

This mid-1940s aerial postcard of the iconic Los Angeles City Hall gives an idea of Court Flight's location. Going west (left) from city hall is the Hall of Records and, across Broadway, the Hotel Broadway and the adjoining dirt strip where Court Flight had been ripped up. City hall, the block-sized Hall of Justice (top), and the Times Building (lower left corner) are all that remain today.

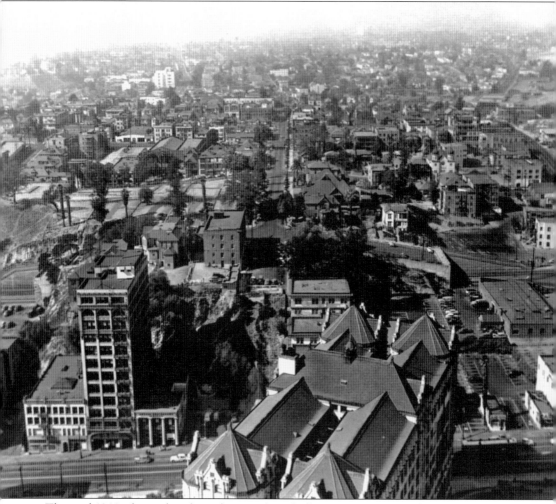

This mid-1940s shot, taken from the top of city hall's 28-story tower, looks west over the roof of the Hall of Records toward Bunker Hill's Court Hill section. Broadway runs horizontally across the bottom of the photograph. Court Street is the most prominent thoroughfare, running up the middle past Olive Street, Grand Avenue, Bunker Hill Avenue, and Hope Street; Temple Street runs vertically in the upper right half of the photograph. Court Flight (just below the middle of the picture) has already been hauled away. The top of the north entrance of the block-long Hill Street Tunnel is visible just to the right of the center. The two-story, white frame house just above it was Burt Lancaster's home in the classic 1949 film noir *Criss Cross*. The construction of the Santa Ana Freeway and the later razing of Bunker Hill obliterated nearly everything in this photograph. (Bison Archives.)

Seven

Hard-Boiled Memories

Angels Flight appeared in many books and short stories. It even inspired the titles of five novels. In Don Ryan's *Angel's Flight*, a 1927 mix of memoir and fiction, the observation tower's camera obscura provided a disenchanted Los Angeles reporter with a metaphor of a disembodied angel looking down upon the faded image of a city. Twenty years later (1947), in Edward N. Holstius's *Angel's Flight*, a British con man thought of the railway as a symbol of American innocence. In Lou Cameron's 1960 paperback novel, *Angel's Flight*, a white Los Angeles musician in a black jazz combo saw the funicular as a nutty little railroad connecting one set of mean streets with another. For Tracie Peterson and James Scott Bell in their religiously themed *Angels Flight* (2001), it added a touch of Christian imagery to a story about a young female attorney defending disenfranchised minorities in 1904 Los Angeles. But Angels Flight made its most famous appearance in *Angels Flight*, Michael Connelly's best-selling 1999 entry in his Hollywood Homicide detective series featuring Hieronymous "Harry" Bosch, who saw the incline as a connection to both his own and the city's troubled past.

Raymond Chandler—who lived on Bunker Hill at the Gladden Apartments at 100 South Olive Street in 1916 and later, in 1938, with his mother at the Palm Terrace Apartments at 625 West Fourth Street—visited Angels Flight in a novella called *The King in Yellow* and in the Philip Marlowe novel *The High Window*. But if Angels Flight had a poet, it was John Fante, a young Italian American from Colorado who lived at the Alta Vista apartments at the corner of Third Street and Bunker Hill Avenue in the early 1930s with dreams of becoming a writer. In his second novel, *Ask the Dust* (1939), Fante so vividly evoked Bunker Hill's atmosphere and topography that today Angelenos consider it a local literary classic. Later in his life, after diabetes ended his screenwriting career, Fante dictated to his wife his last novel, *Dreams from Bunker Hill*, published in 1982, a year before his death.

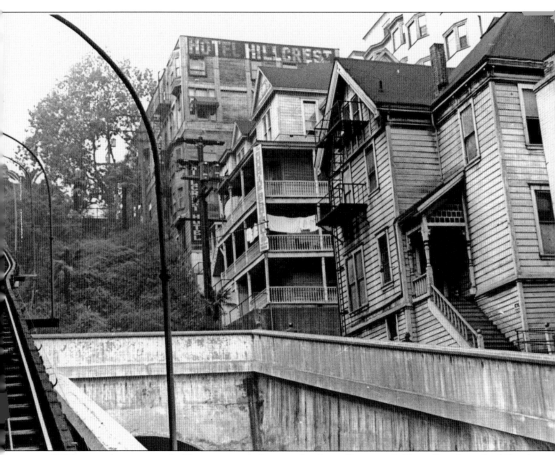

"Old town, lost town, shabby town, crook town," is how Raymond Chandler described Bunker Hill in *The High Window* (1942). He was elaborating on a description he had written earlier in a 1938 novella called *The King in Yellow*: "old town, wop town, crook town, arty town," whose inhabitants ranged from "down-at-the-heels ex-Greenwich villagers to crooks on the lam, from ladies of anybody's evening to County Relief clients brawling with haggard landladies in grand old houses with scrolled porches, parquetry floors, and immense sweeping banisters. . . . It had been a nice place once, had Bunker Hill, and from the days of its niceness there still remained the funny little funicular railway, called Angel's Flight, which crawled up and down a yellow clay bank from Hill Street." Chandler noted in *The High Window* that Bunker Hill had once been "the choice residential district of the city, and there are still standing a few of the jigsaw Gothic mansions. . . . They are all rooming houses now." Pictured are the McCoy house, the Sunshine Apartments, Hotel Hillcrest, and Angels Flight in 1946. (Bison Archives.)

Raymond Chandler (1888–1959) was born in Chicago and was raised in England, but his atmospheric Philip Marlowe novels like *The Big Sleep*, *The Long Goodbye*, and *Farewell My Lovely*—not to mention his screenplays for *Double Indemnity* and *The Blue Dahlia*—defined Los Angeles and the "hard-boiled" literary tradition. After Chandler arrived in Los Angeles in 1913, among his first residences was an apartment on Bunker Hill. (*Herald-Examiner*/LAPL.)

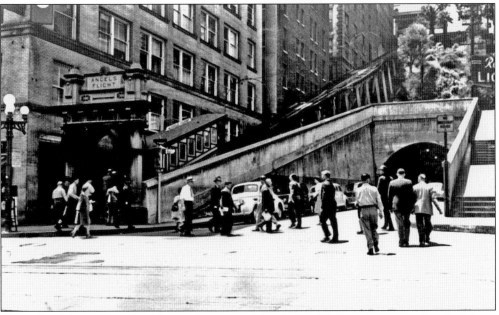

"Steve drank his coffee, asked for another cup and drank that. He lit a cigarette and walked down the long hill to Fifth, across to Hill, back to the front of Angel's Flight, and got his convertible out of the parking lot," wrote Raymond Chandler in *The King in Yellow*, from the March 1938 issue of *Dime Detective* magazine. (Jim Walker.)

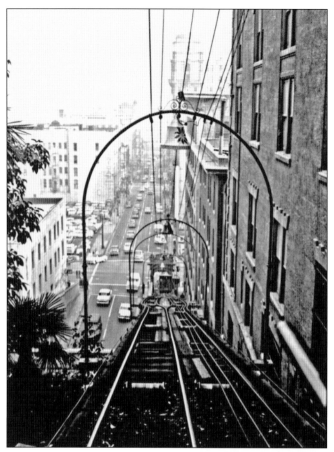

"A triple-gauge track ran up the slope at an impossible angle. It looked steeper than a playground slide. Running on the tracks were two dinky yellow cars attached to opposite ends of the same steel cable. At the top of the hill stood a winch house where a big steel drum pulled one car up and the other one went down, like a yo-yo. The cars were built like lopsided Toonerville Trolleys that got stepped on. They were all out of shape so that the passengers could sit upright as they rode up the hill. The floors of the cars were built like flights of stairs and gothic windows were staggered like steps up the yellow sides of the cars. I guess you might say they were quaint," wrote Lou Cameron in his 1960 *Angel's Flight*. Angels Flight is seen here in the early 1960s. (Photographs by Jeffrey Robbins.)

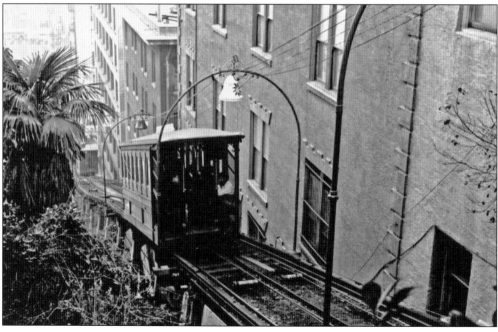

Lou Cameron, in *Angel's Flight*, described, "There was a ding ding from one of the cars and it started up the slope of Angel's Flight. A girl screamed. One always did. Beside me, somebody said, 'I wonder what's up there. Up there on top?' 'Same thing as down here,' I answered. 'Couple of bars, a chili parlor, and a whorehouse.'" (Jeffrey Robbins.)

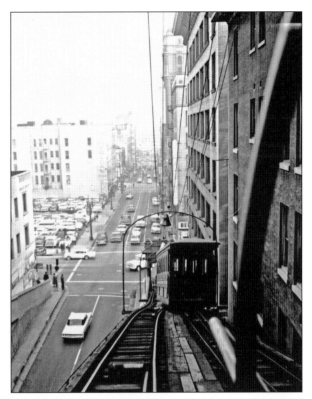

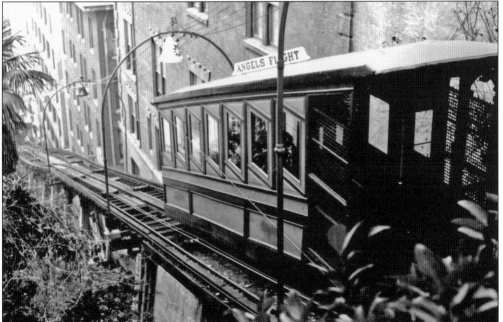

"After eating breakfast in a drugstore, we took a walk. Red liked riding on Angel's Flight, the little cable car [that] climbs from the dirt of Hill Street into the street above. So we walked there and took a ride up. Little things like that seemed to give Red quite a kick," wrote Edward N. Holstius in his 1947 *Angel's Flight*. (Jeffrey Robbins.)

When budding writer John Fante (1909–1983) arrived in Los Angeles in 1932, he found cheap lodgings on Bunker Hill. The atmospheric neighborhood so inspired him that it became one of the most memorable characters in his stories, including his novels *Ask the Dust* and *Dreams from Bunker Hill*. (*Los Angeles Examiner*/LAPL.)

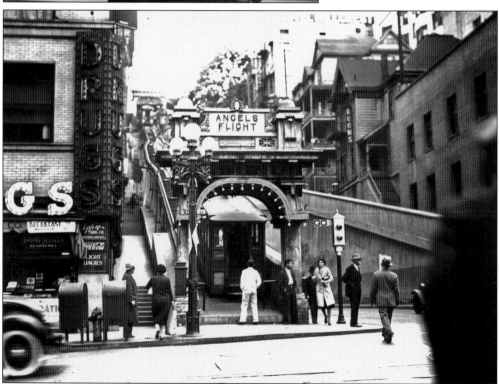

John Fante's 1939 book *Ask the Dust* reads, "I took the steps down Angel's Flight to Hill Street; a hundred and forty steps, with tight fists, frightened of no man, but scared of the Third Street Tunnel, scared to walk through it—claustrophobia. Scared of high places too, and of blood, and of earthquakes." (Bison Archives.)

"[My] hotel was called the Alta Loma," Fante wrote in *Ask the Dust*. "It was built on a hillside in reverse, there on the crest of Bunker Hill, built against the decline of the hill, so that the main floor was on the level with the street but the tenth floor was downstairs ten levels." Fante actually lived at the Alta Vista (right) on Bunker Hill Avenue. (California State Library.)

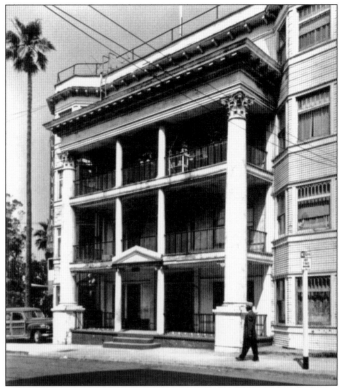

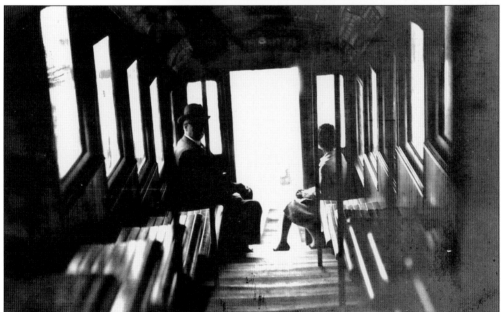

"Walking across Third and Hill to Angel's Flight, I climbed aboard the trolley and sat down. The only other passenger was a girl across the aisle reading a book. . . . As the trolley lurched into motion she moved to another seat. I got off the cablecar at the top of Angel's Flight and started down Third Street toward my hotel," wrote John Fante in *Dreams from Bunker Hill*, published in 1982. (Bison Archives.)

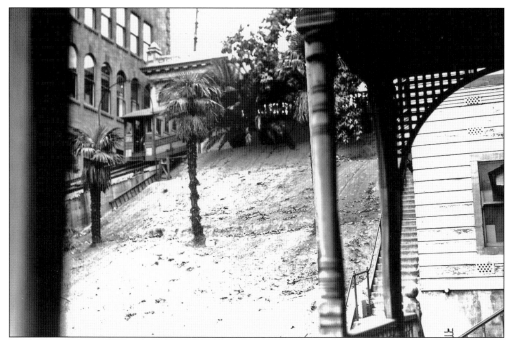

In a 1977 letter to Ben Pleasants, Charles Bukowski wrote, "I found Fante, I'd guess, when I was about 19. He didn't live in a house in this novel but described his window and his place and his hotel somewhere in his writings and it was along the cement stairway opposite Angel's Flight—downtown L.A. I used to pass the place he described and glance at it and quickly pass." (Bison Archives.)

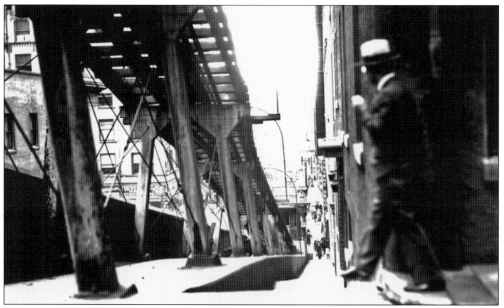

"Bunker Hill was [Fante's] neighborhood," Bukowski explained to Ben Pleasants in a 1978 letter. "I lived there too before they leveled off the poor and put up high-rises. It was the best place for the poor, the best place for cabbage and fish heads, boiled carrots, the old, the insane, the young who couldn't fit into the offices down there." (Bison Archives.)

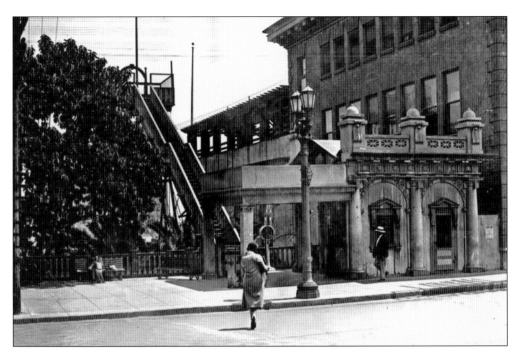

"The groaning cable car landed me above the tops of brittle palms and loquat trees. Another sign invites another ascent. . . . A long flight of wooden steps. Perhaps, beyond, another sign will tempt a rebellious angel to try his wings . . . Angel's flight." So wrote Don Ryan in *Angel's Flight* in 1927. This image was taken the following year. (Bison Archives.)

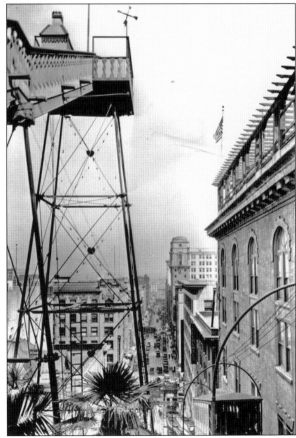

"Again I paid a nickel to ride in the groaning cable car. Again I passed through the ranks of gray invalids in wheelchairs and mounted the long flight of wooden steps. Alone at the summit, I entered the box and closed the door. Darkness giving way to moving shadows— colors appearing—a city of pigmies taking on life in the streets below," continued Don Ryan's *Angel's Flight*. (Bison Archives.)

"As Olivet coursed upward, Sinai came down, the two perfectly balanced cars passing in the middle. In two minutes they were at the top, Ted paying two pennies to the attendant in the wheelhouse. From there it was a short walk to the open-air patio of the Hill Crest Inn that served a four o'clock tea," reads the book *Angels Flight*, written by Tracie Peterson and James Scott Bell in 2001.

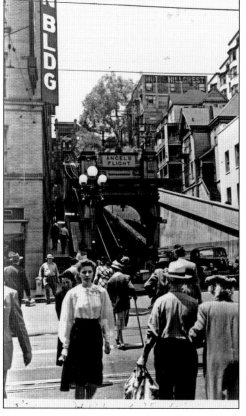

"We followed Perlie all the way downtown on Hill Street, past crumbling apartments with Mexicans sitting on the first- and second-floor porches, and block-long storefronts with signs written in Spanish. Past Washington, Pico, Olympic, and into the shadows of the big downtown buildings, past Pershing Square and then into the mountainous shadow of Bunker Hill where evening comes early whether the sun is shining or not," describes Jim Dawson's *Doghouse*, published in 1992.

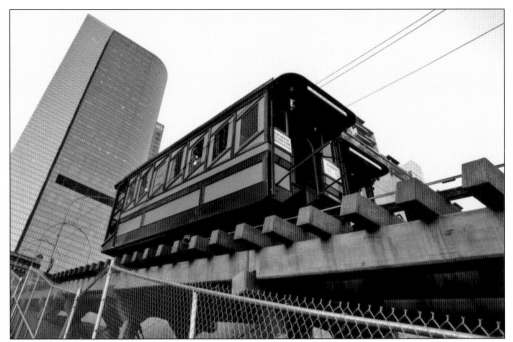

Michael Connelly's 1999 *Angels Flight* reads, "He remembered riding on Angels Flight long before Bunker Hill had been reborn as a slick business center of glass and marble towers, classy condominiums and apartments, museums, and fountains referred to as water gardens. Back then the hill had been a place of once-grand Victorian homes turned into tired-looking rooming houses." (Photograph by Marc Wanamaker.)

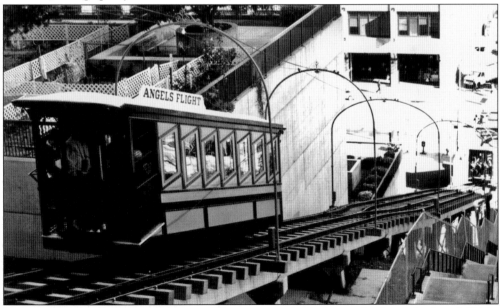

"Angel to some, devil to others, Howard Elias was now dead, shot to death on the Angels Flight railroad. Bosch knew as he looked through the small room's window and watched the orange glow of the laser beam move about the darkened train car that he was in the calm before the storm," Michael Connelly wrote in his book *Angels Flight*. (Photograph by Adam Lebowski.)

"Piccolo always looked forward to the cable car ride up Angel's Flight. When the little trolley began to climb the steep hill, his eyes grew wide with wonder. The crowds on the street looked smaller and smaller. As the cable car climbed higher and higher, Luigi and Piccolo could see the whole city spread out before them," wrote Leo Politi in *Piccolo's Prank*, a 1965 book. Politi also created this illustration. (Politi family.)

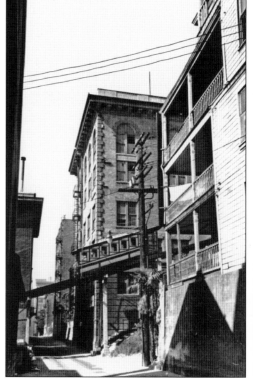

Leo Politi's 1964 book *Bunker Hill Los Angeles* explained, "It was called Clay Street because of the abundant ocher-brown deposits of clay which were used by brick-makers of the early days. It is flanked by old hotels and rooming houses, and lies in the afternoon shade of the Hill." The view looks south on Clay Street past the Sunshine Apartments. (Photograph by Arnold Hylen; California State Library.)

Eight

TRAIN TO NOWHERE

With Hollywood less than a dozen miles away, directors soon came to use the photogenic funicular and its environs as a movie set. The earliest surviving film in which Angels Flight had a starring role was *All Jazzed Up*, a 1920 comedy of errors.

Twelve years later, director James Whale, fresh from filming *Frankenstein*, hauled his camera from Universal Studios to Angels Flight and the Third Street stairway to shoot several scenes for *Impatient Maiden* (1932).

But the railway—along with Bunker Hill—did not get its close-up until the late 1940s, when directors began shooting troubling, starkly lit, almost documentary-style dramas about down-on-their-luck, hard-hit people in postwar urban America. None of the human characters were ever more desperate looking—or compelling—than the Bunker Hill locations themselves. The French magazine *Cahiers du Cinema* later christened these movies *films noir* (dark films).

Among the productions shot on and around Angels Flight were *The Unfaithful* (1947), *Night Has a Thousand Eyes* (1948), *Hollow Triumph* (1948), *Act of Violence* (1948), *Criss Cross* (1949), *Southside 1-1000* (1950), *Once a Thief* (1950), *M* (1951), *The Turning Point* (1952), *Cry of the Hunted* (1953), *Kiss Me Deadly* (1955), a low-budget horror film called *Indestructible Man* (1956), and *Angel's Flight* (1965). Angels Flight also appeared in many television shows, including *Perry Mason* and *Dragnet*. As early as January 20, 1949, *Variety* remarked in its review of *Criss Cross*, "The Los Angeles City Hall, Union Passenger Terminal, Bunker Hill and Angels Flight are all becoming stars or at least featured players in motion pictures."

Documentarians were also drawn to the railway, including Bob Board (*The Derelict* in 1956), Kent Mackenzie (*Bunker Hill* in 1956 and the docu-drama *The Exiles* in 1961), and Edmund Penney (*Angels Flight* in 1964). Thom Anderson's *L.A. Plays Itself* (2004), an assemblage of old movie footage, featured a tribute to Angels Flight. No doubt about it, the railway is a Hollywood icon.

The Al Christie Film Company's *All Jazzed Up* (1920) was a silent comedy about small-town newlyweds Bobby Vernon and Helen Darling honeymooning in Los Angeles. While con men are cheating Vernon out of his money, the wide-eyed Darling is compulsively riding Angels Flight. Finally, she regains her senses and hurries back to their hotel to scribble a note saying, "I was too lonesome here without you. I have gone up Angels Flight—meet me up above." When Vernon returns in a dejected mood and reads his wife's words, he misinterprets them as a suicide note. (Both, UnknownVideo.com.)

In a Romeo and Juliet twist, Vernon is so anguished by his wife's supposed suicide that he decides to kill himself. But nothing works. A streetcar turns away at the last second. His necktie breaks under his weight. And when he tries to drink poison, good Samaritans rescue him. When he shows them his wife's note, they explain that Angels Flight is a railway down the street, not a stairway to heaven. Elated, he runs to the corner of Hill and Third Streets, jumps on *Olivet*, and—seeing Darling coming down on *Sinai*—leaps across to be with her. They presumably live happily ever after. (Right, author's collection; below, UnknownVideo.com.)

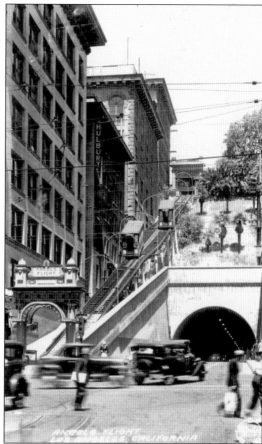

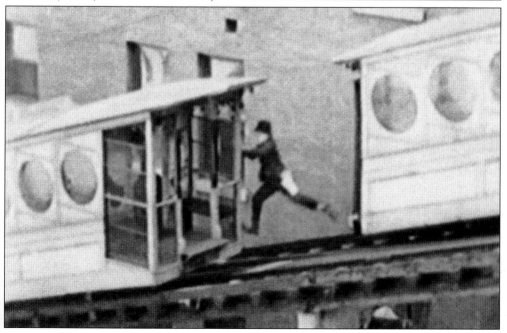

In 1932, director James Whale followed up his classic *Frankenstein* with a melodrama called *Impatient Maiden*, starring *Frankenstein* costar Mae Clarke (kissing Lew Ayres, above) and comedienne Una Merkel (with Monte Montague and Andy Devine, below). The *Impatient Maiden*'s opening scene was shot on the porch of the Sunshine Apartments on the Third Street steps and at the Angels Flight station on Olive Street. Because sound cameras were unwieldy in the early 1930s, Whale shot the sequence with a smaller silent camera and later dubbed in the voices and the din of the city. For an impressive interior scene of Clarke and Merkel riding Angels Flight down to Hill Street, set designers built a mock-up of a trolley in front of a rear-projection screen. (Both, Universal Pictures.)

In director Frank Zinnemann's noir *Act of Violence* (1948), Van Heflin's comfortable life with his wife, Janet Leigh (above, in an early role), is thrown into a tailspin when a stalker, Robert Ryan, shows up with a gun, looking to get even for a betrayal that occurred in a German POW camp during the war. Heflin flees to the anonymous precincts of Bunker Hill and takes refuge with a local barfly and prostitute (Mary Astor), who introduces him to local hit man Berry Kroeger (below). But eventually Ryan finds Heflin and chases him through the hill's streets and down the steps alongside Angels Flight. (Both, MGM/UA.)

The Turning Point (1952) was shot all over downtown Los Angeles and on Bunker Hill. In one scene (above), as William Holden and Alexis Smith take one of the Angels Flight trolleys up the hill, the camera pans over to the Sunshine Apartments, where a female witness is waiting in hiding to talk with them. After getting off at the station house on Olive Street, Holden and Smith walk down the stairway to the apartment house, but when they see several thugs standing guard on the front porch, they quickly hide in another doorway. (Both, Paramount Pictures.)

In many postwar films, the shabby Sunshine Apartments were a symbol of worn-down lives even though the building was less than 50 years old; in 1948 alone, it was Edward G. Robinson's hideout in John Farrow's *Night Has a Thousand Eyes* (Robinson's character called Bunker Hill "strictly a no-questions-asked area") and the place where Dan Duryea and Burt Lancaster planned their ill-fated armored car robbery in Robert Siodmak's *Criss Cross*. Above, Yvonne DeCarlo stands by the window of a threadbare room as *Sinai* and *Olivet* crisscross behind her. At right, the darkened interior of an Angels Flight trolley appears to await another clandestine assignation. (Above, Universal Pictures; right, Jim Walker.)

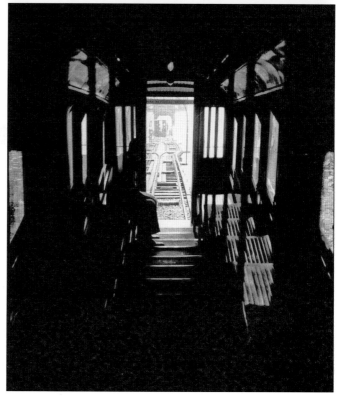

In *Hollow Triumph* (also known as *The Scar*) from 1948, Paul Henreid (with Joan Bennett, above) starred as "a man who murdered himself—and lived to regret it." After stealing money from a local mobster, Henreid kills and assumes the identity of a psychiatrist who looks just like him, without realizing that the victim had a few enemies of his own. At one point, Henreid evades two hit men (Jack Webb and Dick Wessel) at Third and Hill Streets by hopping onto one of the Angels Flight trolleys and kicking Wessel off the car as the thug tries to chase him up the track. Henreid also produced *Hollow Triumph* for independent Eagle Lion Films.

In 1951, downtown Los Angeles replaced Weimar-era Berlin in Joseph Losey's remake of Fritz Lang's 1931 German classic, M, the story of a child murderer played by David Wayne in the original Peter Lorre role. The film was shot on location around the city, primarily on the streets of Bunker Hill and inside and on the roof of the Bradbury Building at Third Street and Broadway. In the photograph above, Wayne's character flees an accuser with one of his victims in tow at the foot of Angels Flight. At right, he contemplates his next victim on a park bench at the corner of Third Street and Bunker Hill Avenue above the Third Street Tunnel's western terminus. (Both, Bison Archives.)

Indestructible Man (1956) was as low budget as they come, but it contains wonderful coverage of Angels Flight and Third Street. After scientists bring an executed murderer (Lon Chaney Jr.) back to life, he takes revenge on the men who testified against him. One four-minute scene follows him up Angels Flight to the Olive Street station and over to the Hillcrest Hotel. Meanwhile, Chaney's ex-girlfriend (Marian Carr, below), who is following him, sees one of his victims at the bottom of Third Street and takes Angels Flight back down to warn him, but she cannot get to the man in time. He walks up the long steps to the Hillcrest Hotel, where Chaney confronts him.

Funicular Used To Build Drama

One of the few funicular railways remaining in public use in the United States, the 53-year-old Angel's Flight rising from Los Angeles' original business section to once-fashionable Bunker Hill, now a blighted area, is a unique setting used for one of the most dramatic sequences of "Indestructible Man," starring Lon Chaney, now at the theatre.

In featured roles are Casey Adams, Marian Carr, Stuart Randall and Ross Elliott, with Chaney portraying a man brought back to life after being executed for murder, and who cannot again be killed in his new life phase.

The picture was produced and directed for Allied Artists by Jack Pollexfen.

Robert Aldrich's *Kiss Me Deadly* (1955) may be the greatest Los Angeles noir of them all, starring Ralph Meeker (interviewing Strother Martin, above, and being taken for a ride by Jack Lambert and Jack Elam, below) as writer Mickey Spillane's hard-bitten detective, Mike Hammer. Shot all over the city in late 1954, *Kiss Me Deadly* spends plenty of time on Bunker Hill's vertiginous array of internal and external staircases. One long scene follows Hammer from Clay Street to the Hillcrest Hotel, with Angels Flight and its Olive Street station visible from the desk lobby. *Kiss Me Deadly* almost wallows in the seedy, broken-down atmosphere that had overtaken Bunker Hill by the mid-1950s. (Both, MGM/UA.)

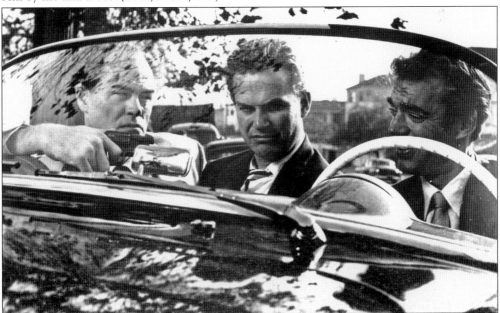

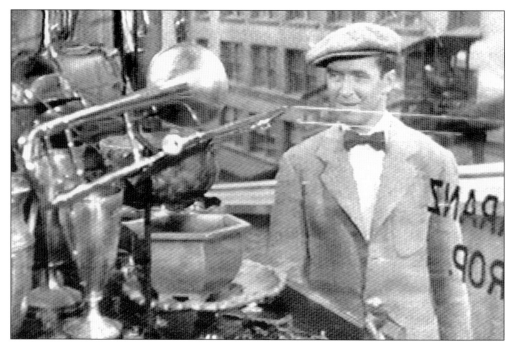

In *The Glenn Miller Story* (1953), Jimmy Stewart portrays the 1930s Big Band leader who perished in World War II. The film begins with Stewart at a Clay Street pawnshop at the Third Street steps. The shop was a facade that covered part of an existing clapboard building (the McCoy house). Add-on windows jutted over the steps so that Angels Flight's orange cars (rarely seen in color before this film) were visible through the front and side glass. In all, during the first 10 minutes of the film, Stewart visits Clay Street three times. (Both, Universal Pictures.)

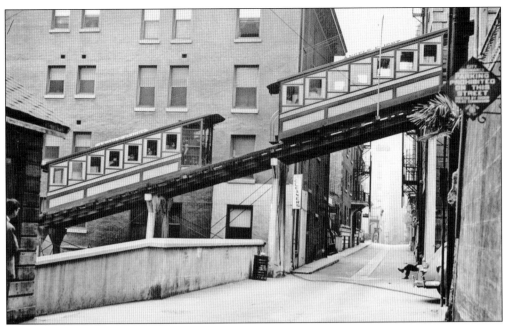

This mid-1950s studio location photograph (above) looks south down Clay Street beneath Angels Flight, a popular filming spot. When directors shot here, they invariably arranged for *Sinai* and *Olivet* to pass each other for maximum visual effect. The Hulburt Apartments building stands behind the railway on the corner. To the immediate right of the photograph is the retaining wall beneath the Sunshine Apartments. The concrete barrier along the street on the left protected pedestrians from falling down onto Third Street at the mouth of the tunnel. Other films shot here include *Impatient Maiden* (1932), *Act of Violence* (1949), *The Glenn Miller Story* (1953), *Kiss Me Deadly* (1955), *Indestructible Man* (1956), *The Exiles* (1961), and *Angel's Flight* (1965). Below, June Havoc has driven beneath the Angels Flight trestle in *Once a Thief* (1950) and has parked beneath the Sunshine Apartments. (Above, Bison Archives; below, author's collection.)

In Kent Mackenzie's semi-documentary *The Exiles* (1961), a community of Native Americans plays themselves (above) in a dramatization of their daily struggle against cultural prejudice, poverty, and hopelessness in a Clay Street tenement. Among the actors were Yvonne Williams (in the white coat), Homer Nish, and Tom Reynolds. Five years earlier, Mackenzie also directed a short student film at the University of Southern California called *Bunker Hill*, following several aging pensioners who lived in what was a close-knit neighborhood. At left, Italian actor Vittorio Gassman takes a breather on one of the trolleys after making a mad-dash escape from lawmen through the Third Street Tunnel and up Angels Flight in *Cry of the Hunted* (1953). (Above, Milestone Film and Video and the Mackenzie Estate; left, Bison Archives.)

Nine

END OF THE LINE

As early as 1929, a local developer named C. C. Bigelow proposed removing Bunker Hill—all 20 million cubic dirt yards of it. "Bunker Hill has been a barrier to progress in the business district of Los Angeles, preventing the natural expansion westward," he said. Bigelow probably would have made good on his threat if the stock market had not crashed later that year. But the ensuing Great Depression and World War II only postponed the inevitable. Bunker Hill's inhabitants were mostly retirees and low-level working-class people with no political heft—and the great majority of them were renters. According to the 1940 census, the neighborhood's population density had increased almost 20 percent in the previous decade because of an influx of mostly Mexican and Italian immigrants. Most of the hilltop's business taxes came from parking lots.

Architecturally, Bunker Hill was an island of forlorn 19th-century survivors in a determinedly 20th-century city that had rejected Victorian artifice and filigree. Nothing had been built there since 1930. By the 1950s, Bunker Hill was not just decrepit and standing in the way; it was gauche. In 1951, Los Angeles's newly formed Community Redevelopment Agency (CRA) began its mission by declaring Bunker Hill "Blighted Area Number One"—"blighted without hope of piecemeal restoration." Three years later, the city council unveiled the first of a succession of blueprints of a more perfect Bunker Hill that would reverse the migration of business from downtown to the suburbs.

By the end of the decade, the freeways had already begun whittling away Bunker Hill's northern and western edges. The Building and Safety Department reported that 60 percent of its buildings were dangerous and another 16 percent substandard. The crime rate was twice that of other neighborhoods. In 1961, the CRA began a scorched-earth policy of buying up property, lot by lot, and immediately bulldozing whatever was on it to further encourage nearby owners to bail out of the neighborhood. The fate of Bunker Hill was sealed in 1962 when the CRA acquired Angels Flight for $35,000.

By 1930, even Bunker Hill's most residential street, Bunker Hill Avenue, looked worn down, with its once-splendid Victorian homes now broken up into rented rooms and cheap apartments. But the neighborhood was still thriving. In this southward view down the 300 block toward Fourth Street (above), the Donnigan "Castle" stands on the right, and the 1931 art deco–style Southern California Edison Building on Fifth Street can be seen on the left. Turning around and looking north on Bunker Hill Avenue from only a few steps away (below), the Castle is now on the left. (Both, Bison Archives.)

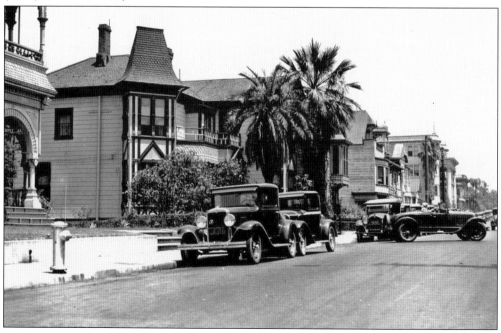

"The silent and aloof towers that dominate [Bunker Hill] today are sufficient proof that the attempted expurgation of the carpenter and shoemaker, the corner druggist and news vendors, the barkeeps and park-bench bums and the enclaves of black and Navajo Indian families whose homes disappeared beneath the four-level exchange, was a dangerous gambit. The abstracted life that fills those mighty tombstones, and departs from them hurriedly at dusk, is a dark doppelganger of the neighborly life that wanted nothing more than to stay put, to root itself deeper. Of course, that community never had the power to resist, which is exactly why it was ejected," wrote Greg Goldin in a 2004 *Los Angeles Times* article. The photograph above looks north up the 300 block of Clay Street from Fourth Street; the shot below shows the same buildings from the opposite direction. (Both, Bison Archives.)

"Many of the loyal customers who daily left the hill to come downtown no longer live on the hill. Their nineteenth-century homes and apartment houses have been battered down by progress or burned down by carelessness," said Art Seidenbaum in the *Los Angeles Times* in 1964. The Koster House in this 1946 photograph stood on Second Street between Grand Avenue and Olive Street. It was featured in the 1949 film noir *Shockproof*. (Bison Archives.)

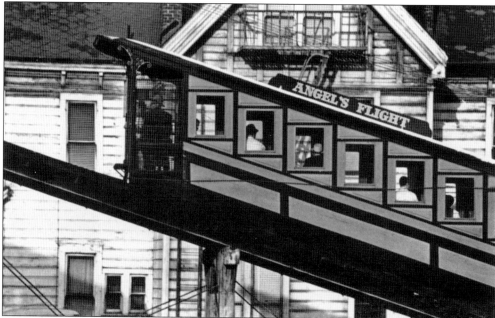

"When the funicular ride was newfangled more than 60 years ago, it was framed along the route by buildings to match," commented Art Seidenbaum in the *Los Angeles Times* in 1964. "For every curving metal ornament on Angel's Flight, there was a wooden grace note on a building, carved on a gable, gnarled beneath an eave, patterned into lattice." The photograph shows a trolley telescoped against the McCoy house. (Security Pacific Collection/LAPL.)

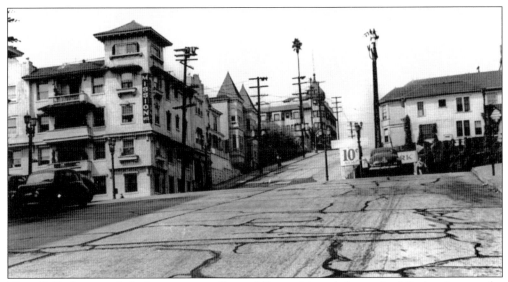

This 1945 photograph looking west up Second Street (above) shows the Mission Inn on the southwest corner of Olive Street and the Dome Hotel, formerly the Minnewaska, on the northwest corner of Grand Avenue near the top of the hill. On the right is the Koster House. For many years, Second Street was Bunker Hill's most commercial thoroughfare. (Bison Archives.)

Looking east up Second Street in 1950 from the opposite side of the hill, the Dome Hotel on Grand Avenue is on the right. Hope Street cuts across the bottom of the picture. The houses facing away from the camera in the upper left of the photograph are on the west side of the 100 block of Bunker Hill Avenue. (Bison Archives.)

Cinnabar Street was a block of apartment buildings that ran from Second to Third Streets between Flower Street (to the west) and Hope Street. It was named after a reddish, mercury-bearing ore once used to make vermilion dye. In this 1958 photograph looking south down Cinnabar toward Third Street, the Richfield Building on Figueroa Street near Fifth Street is visible in the distance. (Photograph by Arnold Hylen; Bison Archives.)

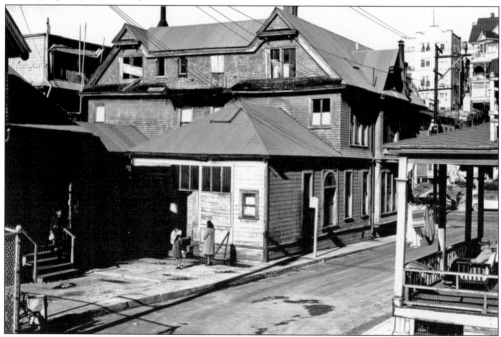

Olive Court was an out-of-the-way, U-shaped alleyway off Olive Street between First and Second Streets. It was a cozy neighborhood of pensioners and poor working families. In this 1955 photograph looking west, the large boardinghouse on the left fronted on Olive Street. In the background at the top of the hill are the backsides of the Melrose and Richelieu hotels on Grand Avenue. (Photograph by Leonard Nadel; Bison Archives.)

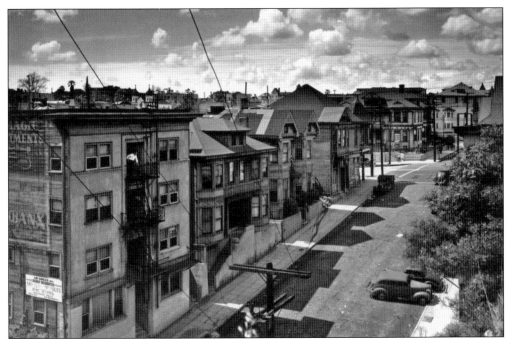

A 1939 view up the 400 block of First Street from Hill Street shows a Bunker Hill neighborhood of aging rooming houses inhabited by day laborers, poor people, seniors scraping by on pensions, derelicts, and shady citizens hiding out from the rest of society. (Photograph by William Reagh; Security Pacific Collection/LAPL.)

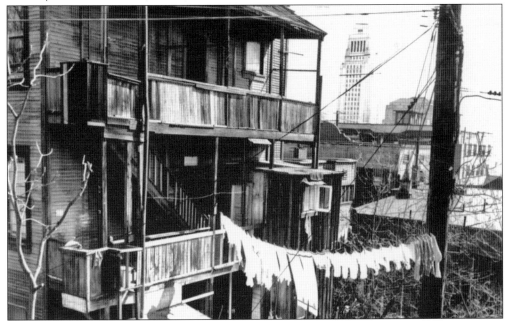

By 1951, as the postwar real estate boom was opening bright new suburbs for ex-soldiers and their families, Bunker Hill had become a forgotten community. This apartment building at 512 West First Street was exactly what the CRA branded most local housing: a slum. (Photograph by Leonard Nadel; Security Pacific Collection/LAPL.)

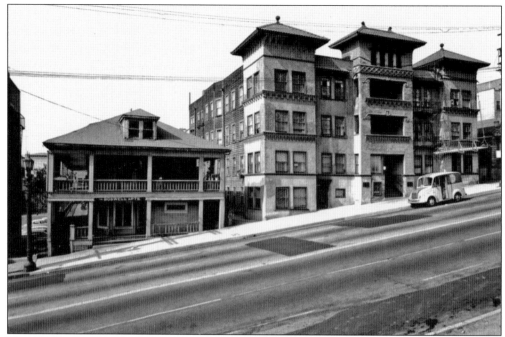

The 300 block of South Flower Street, like most of Bunker Hill, was hanging on in 1955, despite the slow destruction going on around it. The Boswell Apartments on the left later burned down under mysterious circumstances. The St. Regis Hotel on the right was razed in the mid-1960s. (Bison Archives.)

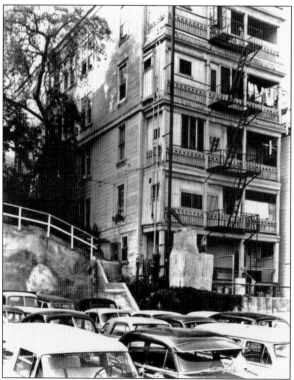

The CRA's 1969 "Design for Development" report proposed that it was important "to preserve and enhance that awareness of elevation—the project's most dramatic natural asset, the topographic features which give Bunker Hill a strong sense of place." Revitalization was supposed to stress "the creation of a quality environment for people." But first, old apartments like 224 South Olive Street (left), seen from the rear, had to go. (Bison Archives.)

In 1963, in an introduction to her history of Bunker Hill, Patricia Adler saw the coming devastation: "Stately homes turned rooming houses, simple frame cottages, stucco-fronted apartments—the whole assemblage from which the past could be read first hand will have vanished. Every structure on the hill is to be demolished, the streets reoriented, and the summit leveled off to make way for redevelopment. Nothing will remain but the inner core of the hill's ancient contours, the official records of land bought and sold, and references on the printed page to its short hundred years as part of Los Angeles life." At right, the Melrose Hotel on Grand Avenue was torn down in one day in 1957; below is the stranded Moorcliff apartment building at 121 South Hill Street in 1951. (Right, Bob Board; below, Security Pacific Collection/LAPL.)

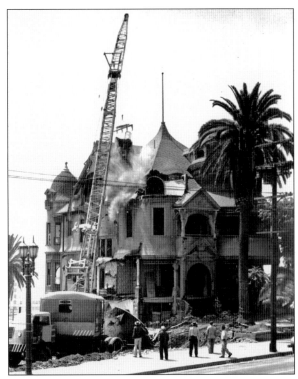

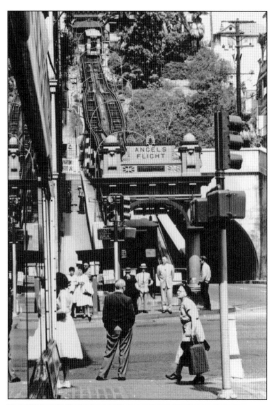

By the early 1960s, as Bunker Hill's buildings fell at a faster rate, Angels Flight's days were numbered. But the little cars continued to ply their trade, transporting thousands of residents and tourists each day. The photograph at left looks up the south steps that climbed past several businesses in the sides of the Ferguson and Hulburt buildings. Below, the Third Street corridor's buildings are intact, but time is running out. The two buildings at the top of the hill will be the first to go. (Left photograph by Arnold Hylen; California History Section/California State Library; below photograph by Jeffrey Robbins.)

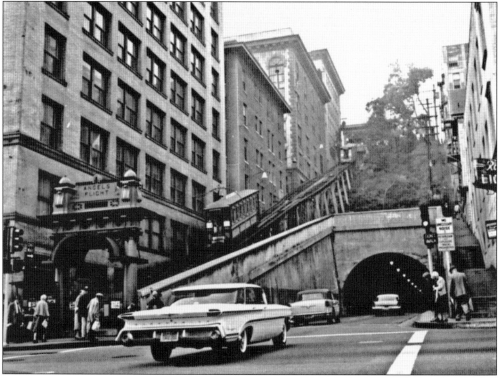

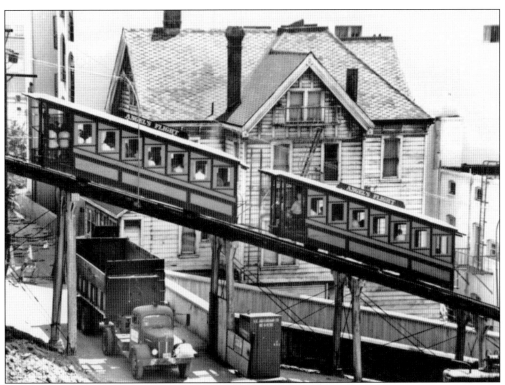

Already the large brick buildings at the southwest and southeast corners of Clay Street have been torn down (above), as a dump truck waits above the Third Street Tunnel to pick up more dirt and debris—and *Olivet* and *Sinai* pass each other overhead. The McCoy house in the background looks like it has been emptied of residents, but it will hang on until the end. Pictured right, what looks like a construction worker walks up the south steps toward Clay Street below the tracks and concrete pillars of Angels Flight. (Photographs by Arnold Hylen; California History Section/California State Library.)

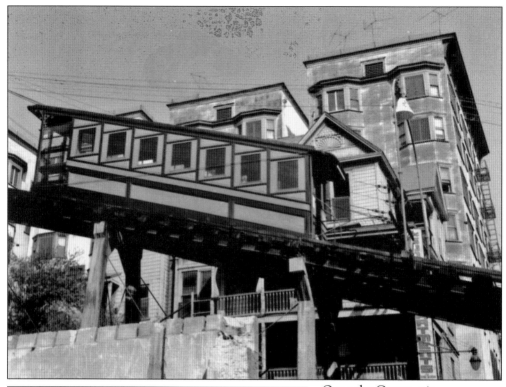

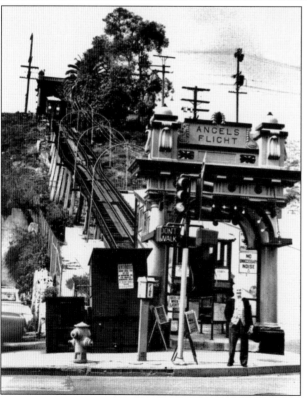

Once the Community Redevelopment Agency's destruction of Third Street's corridor of commercial and apartment buildings had begun, there was no turning back. Above, a lonely Angels Flight car glides past the derelict Sunshine Apartments; behind it are the Blackstone Apartments, also empty; and beneath the tracks stands the concrete remnants of the Nelson Building. In the photograph at left, the Sunshine Apartments are gone, along with everything else above Clay Street. The little railway looks more forlorn and useless than ever, running habitual errands above weed-choked vacant lots and broken masonry. (Above photograph by Jeffrey Robbins; left, Bison Archives.)

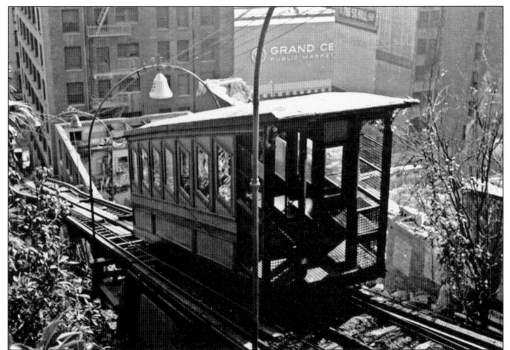

In 1961, W. W. Robinson wrote, "Even among those Angelenos who never use the little cars—and most of us are in that class—there is a feeling of nostalgia aroused by the sight or thought of Angels Flight. It is part of the present that seems to belong to the past." Mayor Sam Yorty's assistant, Robert Goe, addressed the problem in 1961 when he said the city might want to acquire Angels Flight: "We are considering moving the unit to some location such as the Griffith Observatory, the Hollywood Bowl, the Greek Theater or Traveltown, where it might continue to be useful." (Above photograph by Jeffrey Robbins; below, Bison Archives.)

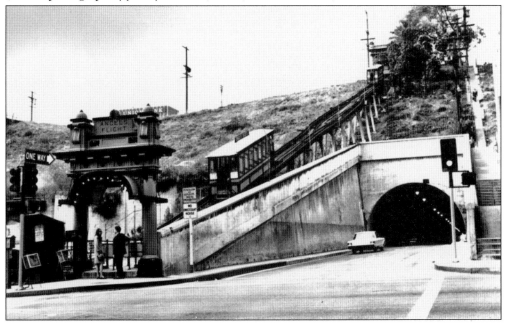

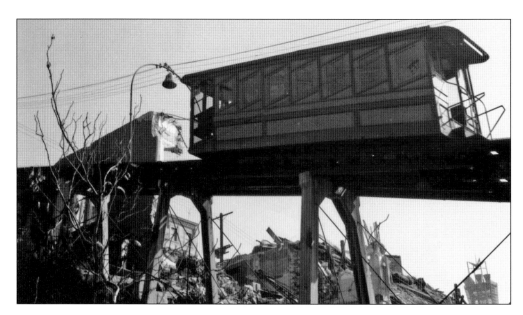

History-minded folks took a second look at Bunker Hill as it fell away into memory. They worried about Angels Flight. What would happen when no more riders lived on the hill? And with the top of Third Street slated to be lopped off, the upper part of the incline would be literally in the air—convenient for winged angels but no one else. Eventually, the area of Olive and Third Streets—the top of Angels Flight—would be reduced in height by 40 feet. The two buildings left standing in the photograph below were the Ems Apartments (left) and the Casa Alta Apartments (formerly the Palace Hotel) on Olive Street. (Above photograph by Jeffrey Robbins; below, Bison Archives.)

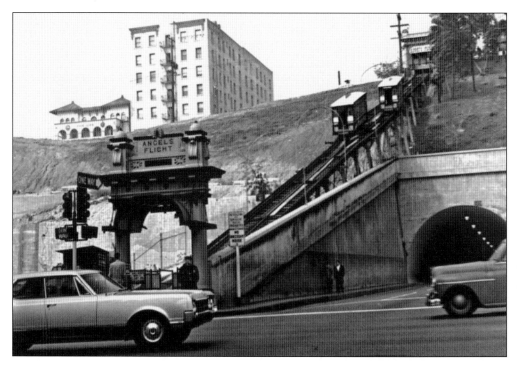

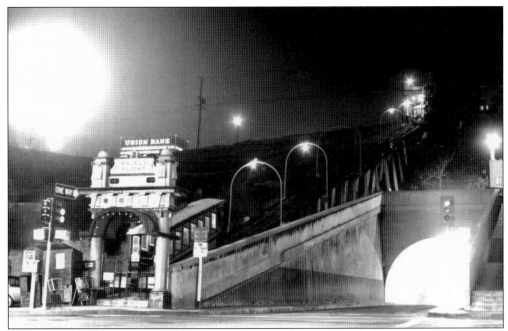

"When we were filming [*Angel's Flight*] in the early sixties, there were bulldozers and cranes with wrecking balls up there, we heard them all the time. We shot early or late in the day mostly so the noise wouldn't mess us up. One night after we finished shooting, it must have been long after midnight because the air was misty and the whole neighborhood was quiet. I walked down the steps thinking how abandoned Angels Flight looked in the moonlight. We knew even then that it was just a matter of time before the wrecking crews got around to tearing it down, too," remembered *Angel's Flight* actor William Thourlby about the movie's filming in 1996. (Both, Jim Walker.)

As Bunker Hill was being torn down, actor and director Bob Board (left, above) shot a short film called *The Derelict* near the Dome Hotel on Second Street with television star Lauren Chapin (*Father Knows Best*), seen here with her mother, Meg Chapin. "I wanted a neighborhood that looked as down and out as my characters," Board said in 2008, "and you couldn't find a place that looked more broken down than Bunker Hill in those days." Singer Peggy Lee (seen below, riding in one of the cars on November 1, 1968) was one of several celebrities who campaigned to save Angels Flight. (Above, Bob Board; below, *Herald-Examiner* Collection/LAPL.)

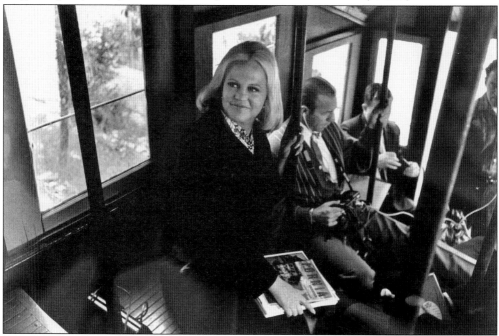

Dwarfed by the Union Bank Building, Bunker Hill's last surviving Victorians—Dr. Edward Cook's 1880 "Salt Box" and the 1882 Donnigan "Castle"—await their move to the Highland Park section of town, adjacent to the Pasadena Freeway, to form the backbone of a 19th-century showplace called Heritage Square. Both houses originally stood in the 300 block of Bunker Hill Avenue. The city council designated them as historic-cultural monuments, appropriated $42,000 for moving expenses, and towed them away in mid-March 1969. Not long after their arrival at the new location, both buildings were torched by vandals and burned to the ground. For a reminder of the Castle's grander days, turn back to page 15. Below, an Angels Flight car awaits its fate. (Above, photograph by William Reagh, Security Pacific Collection/LAPL; below, author's collection.)

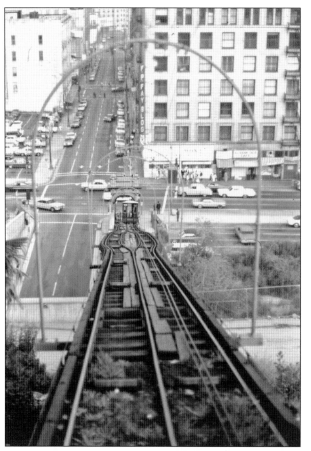

The September 25, 1968, edition of the *Los Angeles Times* announced, "Angels Flight Will Be Razed Temporarily." The Community Redevelopment Agency's best guess was that it would be stored away for less than two years. On March 18, 1969, *Olivet* and *Sinai* were lifted off the tracks, placed onto trucks, and driven to a former laundry building at 1119 West Twenty-fifth Street. The Hill Street archway was taken to 14410 South Avalon Boulevard in Carson. The tracks were ripped up and the elevated structure torn down for scrap. Nothing was left of Angels Flight but a weathered path. Despite all the promises, the little railway would never return to Third Street. After 68 years, the original Angels Flight was just another relic of Los Angeles's history. (Photographs by Jim Walker.)

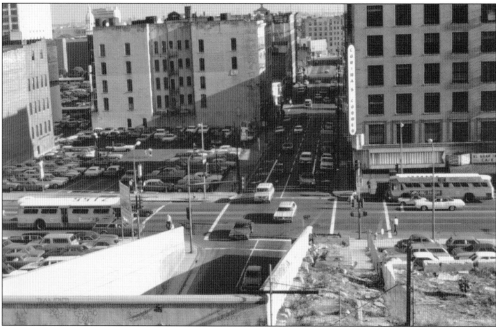

Ten

BACK TO THE FUTURE

With the local economy sputtering throughout the 1970s, the Community Redevelopment Agency did not get around to rebuilding Bunker Hill until the late 1980s. By then, its master plan called for Angels Flight to be restored half a block south from its original site as part of a new California Plaza complex—an office tower, a condominium, a hotel, and an amphitheater and restaurant area called the Watercourt—in the 300 block of South Grand Avenue. The railway would link the Watercourt to the bustling Grand Central Market on Hill Street below. But a recession in the early 1990s scuttled Angels Flight's return.

Nonetheless, several downtown preservationists—including Dennis Luna and attorney John Welborne—pushed the Los Angeles City Council and the CRA to honor their promise to restore the little railway. A few movers and shakers got on board, including the Ahmanson Foundation, the Ralph M. Parsons Foundations, the California Cultural and Historical Endowment, and individuals like best-selling novelist Michael Connelly (*Angels Flight*) and developers Jim Thomas and Forest City Enterprises.

Nearly 27 years after they were hauled away, *Olivet* and *Sinai*, the station house, and the two arches—all restored—were returned to downtown where a new, seismic-resistant, 298-foot trestle, a new set of tracks, and a new cable drive system awaited them at 351 Hill Street. The project's total cost was over $6 million. The fare was set at 25¢ a ride (or five rides for $1). The nonprofit Angels Flight Railway Foundation was put in charge of maintaining the operation. The line reopened in early 1996 and lasted almost five years before a mechanical malfunction—and a fatality—shut it down again.

The Los Angeles Conservancy was an early participant in the many committee meetings and fund-raising events to bring Angels Flight back to Bunker Hill. At one evening party in 1993, it served an Angels Flight cake (above). The Metropolitan Transit Authority also took an interest in rebuilding Angels Flight and provided Los Angeles with a generous grant of $250,000. But the driving force behind the restoration was the Angels Flight Railway Foundation, helmed by attorney John Welborne, which took control of the railway from the Community Redevelopment Agency in 1995. (Above, photograph by Marc Wanamaker; below, photograph by Jim Walker.)

On a sunny, cloudless Saturday, February 24, 1996, Angels Flight returned to downtown Los Angeles, half a block south of its original location, after 27 years of being away. Hill Street was closed off for several blocks, and the Grand Central Market hosted a commemorative street fair. Among the medium-sized crowd were railroad buffs, history aficionados, the simply curious, and grandparents who brought their families and reminisced about childhood jaunts up and down the Third Street hill all those decades ago. There were long lines of ticket buyers at both ends of the railway. A commemorative round-trip ticket cost 50¢. (Photographs by Jim Walker.)

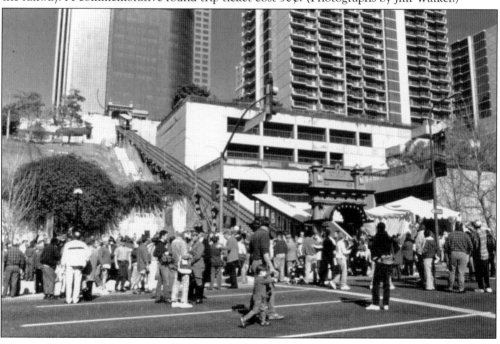

Among the dignitaries and celebrities on hand at Angels Flight's reopening was Huell Howser, KCET-TV's folksy, gee-whiz host of *Visiting . . . With Huell Howser* and several other California-traipsing programs in which he shows up at historical sites, commemorative events, colorful local businesses ranging from menudo factories to roadside diners, and various topographic oddities to interview whoever is in range of his microphone. Angels Flight—quirky, anachronistic, photogenic, and locally beloved—was a perfect subject. Howser, exuding Tennessee charm, circulated among the Hill Street crowd to get reactions from everyone, young and old. The visit to Angels Flight turned out to be one of his most-watched programs. (Photographs by Jim Walker.)

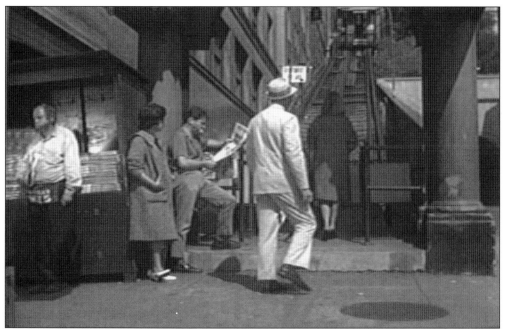

Huell Howser returned to Angels Flight on his *Visiting With . . .* program as part of the rediscovery of the 1965 film noir *Angel's Flight*, which KCET aired along with Edmund Penney's 1964 *Angels Flight* documentary. Blonde Indus Arthur (wearing a coat, above and below) starred as a Bunker Hill serial killer, an "angel in flight," according to scriptwriter Deane Romano—hence the apostrophe in the title. The film, never completed as written, was reportedly stolen by the producers and released briefly as *Shock Hill*. Romano later regained all rights. Thanks to Howser's exposure on public television, *Angel's Flight* ran at Hollywood's Egyptian Theater as part of an American Cinematheque noir festival. (Both, Deane Romano.)

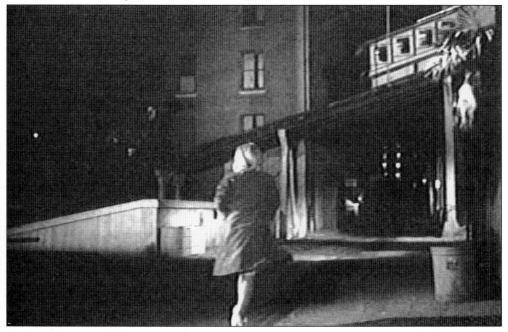

There are many drawings and paintings of Angels Flight by Ben Abril, Frank Mapson, Jake Lee, Streeter Blair, Stan Cline, and other artists, but none of them ever captured the public imagination like Leo Politi (1908–1996), a Fresno-born Italian American painter whose whimsical depictions of old Bunker Hill are considered a local treasure in Los Angeles. After spending most of his youth and training as an artist in Italy, Politi returned to California and spent the rest of his life living on or within walking distance of Bunker Hill. He wrote 30 books—mostly for children—and illustrated almost as many more. When Angels Flight reopened on February 24, 1996, Politi cut the ribbon and took the first ride. A month later, on March 25, he passed away at age 87. A park near Dodger Stadium and an elementary school are named for him. (Photographs by Gary Leonard.)

The most tragic moment in Angels Flight history came almost 100 years after its original opening. On February 1, 2001, a cable slipped from one of the station house's two drums and sent *Sinai* crashing down into *Olivet*, killing elderly tourist Leon Praport and injuring seven others. The National Transportation Safety Board determined that the probable cause was the improper design and construction of the gear and drive system, and the failure of the regulatory bodies to enforce safety standards. The California Public Utility Commission, which oversees all rail lines, blamed the Community Redevelopment Agency, the Angels Flight Railway Foundation, and the Angels Flight Operating Company. Meanwhile, the contractor responsible for many of the flaws fled the country to avoid liability. *Sinai* and *Olivet* were moved into storage at the Metropolitan Transportation Authority. The City of Los Angeles commissioned conductor David Woodard to compose and perform a memorial suite honoring Praport and Angels Flight's cars. It was performed on March 15, 2001, by the Los Angeles Chamber Group as "An Elegy For Two Angels." At this writing in early 2008, despite promises of an eminent reopening, Angels Flight remains a silent railway without its cars. (Cartoon by Doug Davis.)

In his 2003 book Dead Cities, Mike Smith mourned the loss of old Bunker Hill, a place of "Victorian cliff-dwellers connected by a crazy quilt of stairways, narrow alleys, and two picturesque funiculars." Smith saw the Community Redevelopment Agency's master plan of transferring the city's financial district from Main and Spring Streets to the top of Bunker Hill as a way of protecting it from everyday street life (the devastation of the 1965 Watts race riots being still fresh in everyone's mind) and creating a kind of Forbidden City, cut off from the rest of Los Angeles. Perhaps an early-1970s advertisement for new condos on the hill said it best: "You can live above it all at the Bunker Hill Towers." In the photograph above, taken in February 2008, the corner of Third and Hill Streets looks nothing like it did even 40 years ago. Only the tunnel remains. And at this writing, barring another economic downturn, Los Angeles's grand designers are planning yet another monumental skyline change at this fabled corner. (Photograph by Mary Katherine Aldin.)

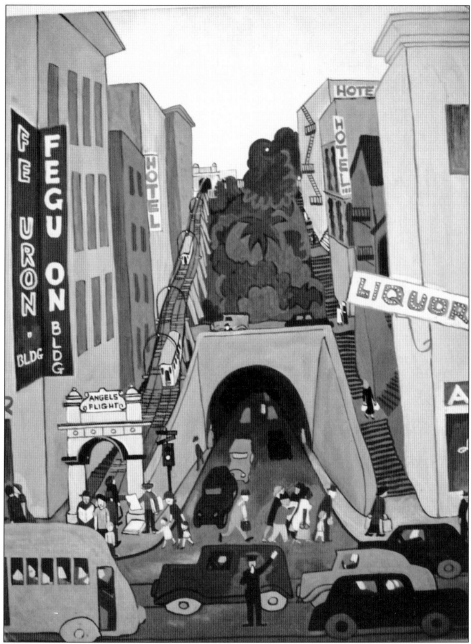

Angels Flight is located at 351 South Hill Street in Los Angeles (coordinates 34.05109 latitude, 118.249868 longitude). The Angels Flight Railway Foundation's address is California Plaza, Bunker Hill Post Office 712345, Los Angeles, CA 90071. Angels Flight was added to the National Register of Historic Places on October 13, 2000. To visit Angels Flight, exit the Harbor Freeway (110) in downtown Los Angeles via Fourth Street and drive east to Hill Street. Parking lots and structures are located nearby. By Metro Rail, take the Red Line to the Pershing Square station and exit at the Fourth Street end. By Metro bus, take the Nos. 1, 2, 3, 4, 10, 11, 48, or 304 lines into downtown Los Angeles and get off at Third Street. The painting of Angels Flight as it looked in the early 1940s, above, is one of several created by the inimitable Leo Politi. (Politi family.)

Across America, People are Discovering Something Wonderful. *Their Heritage.*

Arcadia Publishing is the leading local history publisher in the United States. With more than 4,000 titles in print and hundreds of new titles released every year, Arcadia has extensive specialized experience chronicling the history of communities and celebrating America's hidden stories, bringing to life the people, places, and events from the past. To discover the history of other communities across the nation, please visit:

www.arcadiapublishing.com

Customized search tools allow you to find regional history books about the town where you grew up, the cities where your friends and family live, the town where your parents met, or even that retirement spot you've been dreaming about.